How Colours Unite Us All
A Visual Guide for Creative and Anthropologist Minds

D1262803

Identity **Colour Codes**

BIS Publishers 2014

Introduction

4

Colours brand social identities

Orange

The two young girls wearing bright orange shirts stand on the streets of Amsterdam on 26 April, at the annual King's Day street fair, playing their violin and collecting money from passers-by. The local Surinamese fast food snackbar covers its counters with orange paper displaying the fried bananas and Pom fries. Global beer brewery Heineken sets up the orange Holland House at the Olympics every time as a place for Dutch fans, sponsors and media to celebrate victories. The local entrepreneur, the global player and the performing kids: what they all share is their identification with the Dutch nation in orange, the colour of the royal house. Colour is open; it allows for self-expression like language does, but in context it's a symbol. Orange is like a word: you can combine it with other things and build conceptual 'sentences' with it. But it's also like a sign, a symbol: a very specific meaning associated with a religion, company or culture.

Tomorrow's brands are like these very specific symbols: open systems, to be used by everybody. The more users there are, the stronger the brand becomes. I facebook, you twitter, we google. They function like inclusions.
Brands or Identities based on limited symbolics and protected logos (like we know them) are based on exclusiveness. They're based on centralized ownership and create seperations between holders and followers.
In actual fact, however, identity is about sharing ideas, beliefs or history through a common set of attributes and signs establishing a recognisable sense of identification. This is what makes me me. This belongs to who I am. In this perspective, identity is a ritual that has to be re-affirmed periodically or repeated constantly – similar to rituals like Santa Claus, using my iPhone5 or checking Facebook.

Blue Rituals

Rituals are high-energy situations. At that level of intensity, the participants in the event and the sign/event become one. It was 20th-century anthropologist Émile Durkheim who laid out the theory of collective effervescence in the book *Elementary Forms of Religious Life* by studying rituals of Australian Aborigines. The rare ritual ceremonies were full of 'sacred' energy. That energy condensed in the fusion of physical objects such as totems with the ritual and the participants. The totem is both the representation of the scene and the embodiment of all the emotions felt there. The totem, in short, was the representation of the whole ritual. Today's rituals are far more complex in structure; people do not belong to closed systems, tribes or ideologies, yet communicating over Facebook feels like a ritual. A ritual in which the act of communicating and sharing information with friends fuses with a strong sense of being connected to others. The Facebook platform is the totem. The psychological desire to connect and be part of like minds is not unique to our era; it has always existed, and always will.

In the new reality of the open society, supported through social media and ICT, Durkheim's idea that the 'totems' unite both the scene and the participants' emotions is more relevant than before. We all become 'prosumers' in using social media and information technology: we are both consumers and producers of information while using Facebook. And Facebook itselves accumulates the data of these topics, relations and behaviourial patterns into Big Data.
In the old world, one could distinguish the symbol from the user with a prefabricated, centralised concept. In the new world, the symbol IS the tool and expression of a complete scene in which the user participates, like Durkheim's totem. Collective effervescence arises in high-energy situations.

Red

The Red Cross organisation has tried to align the different national and regional versions of its symbol. In contested areas, the use of the red cross or the red half-moon represents a major risk: Muslims regard the red cross as a Western sign, whereas the Jews similarly do not see the red half-moon as neutral. Doctors and

aid workers come under attack, because they are identified with the 'opposite' party. Although it is an independent organisation with an acknowledged humanitarian purpose, using the red cross in the trenches of a civil war is regarded as non-neutral. The Red Cross has developed an excellent symbol that would encompass all cultural differences: a red diamond. The red diamond has not been adopted worldwide thus far. One of the reasons this ambition failed is that it tried to solve the problem within the domain of symbolism instead of going beyond symbols. A belief system, like the Red Cross, in which all doctors, logistic experts and support professionals should be able to do their work under any and all circumstances, is framed by its symbol, because symbols historically are contested. In fact, the most universal aspect of the symbol of the red cross is 'red', with associations of blood, wounded, emergency aid. Social identities are open, generic yet strongly recognisable, providing a way for the participants to connect, to unite, to participate. In search of the lowest common denominator by which one can unite with others, colour is 'unclaimed territory', accessible to everyone, the lowest common denominator.

Yellow
A shared belief in a nuclear-free world is expressed through yellow. Whether it concerns contested rail transports in Germany, the aftermath of Fukushima or concerns in Central Asia, all those involved adopt yellow as their collective 'totem'. Yellow is the collective brand without a trademark. Organised bodies, institutions and individuals all participate in the scenes of protests and rallies, where colour is the totem that represents the collective identity and, simultaneously, the sign that expresses the 'brand'. In the globalised reality, Nuclear Yellow, Guantanamo Orange, Trust Blue or Black Rock can travel and be adopted in any place or region.

Although we mourn our parents or loved ones in black in the West, funeral attire is white in India or China. On a cultural level, there are differences in colour symbolism. However, there are surprising continuities on a deeper psychological level. Colours seem to follow universal patterns. Yellow, for instance, is connected to the domain of the senses, whereas blue psychologically taps into domains of empathy, sharing and caring.

For instance, today's environmental thinking is now expressed more frequently through blue (like VW's 'Think Blue') than through green. Environmental thinking is now more about being connected to the consciousness of the world around us about educating others. Green seems to be the colour that represents education in the most broadest sense. And red, the most powerful colour, embodies the domain of personal and social development.

Identity Colour Codes shows the richness of colour for social identities to brand the idea, theme or domain that the participants share. Each domain has its own code, in nationalism, politics, religion, regions, culture, lifestyle or sports.

Irish Green

Saint Patrick referred to the Shamrock (three-leaf clover) as a token of the holy trinity.

Islamic Green

In Islam, the colour green symbolises nature and life.

Army Green

Camouflage colour becomes the symbol for military aspect or equipment.

Urban Green

Regaining social autonomy over food cycles. Independent spontaneous urban farming and market projects.

Survivalist Green

Army vets roleplay challenging civic morality in everyday life.

Monster Green

Extreme excitement, extreme fascinations, extra-terrestrial sensations.

Vertical Green

Modernist reconciliation with nature: bringing back organic elements in constructed architectural realities.

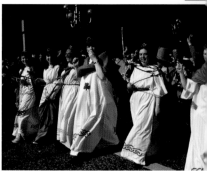

Irish Green

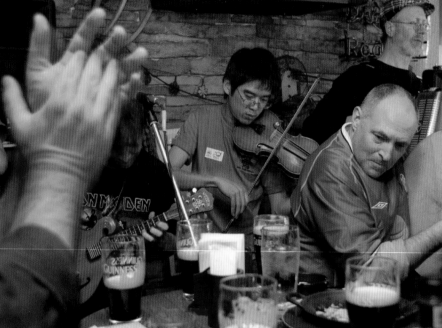

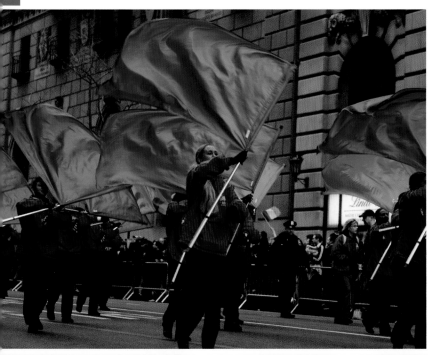

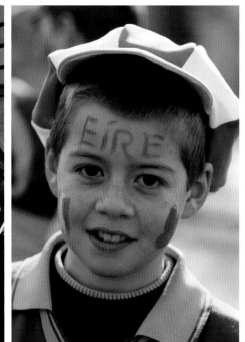

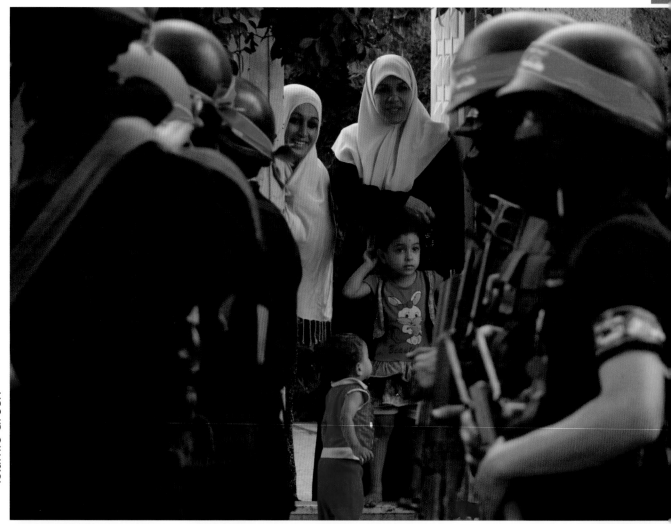

Islamic Green

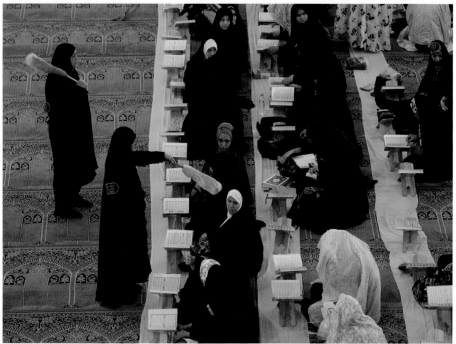

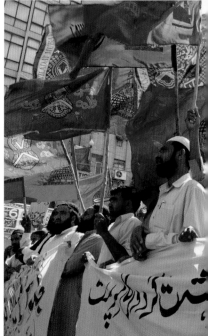

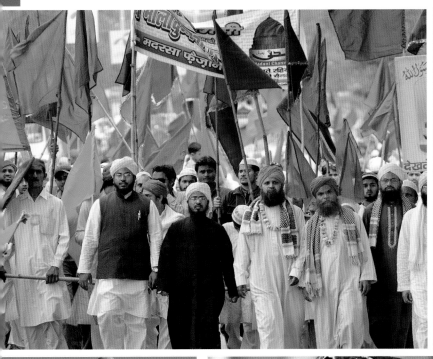

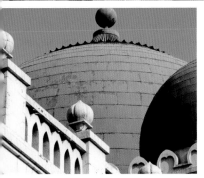

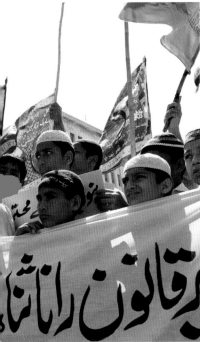

Army Green

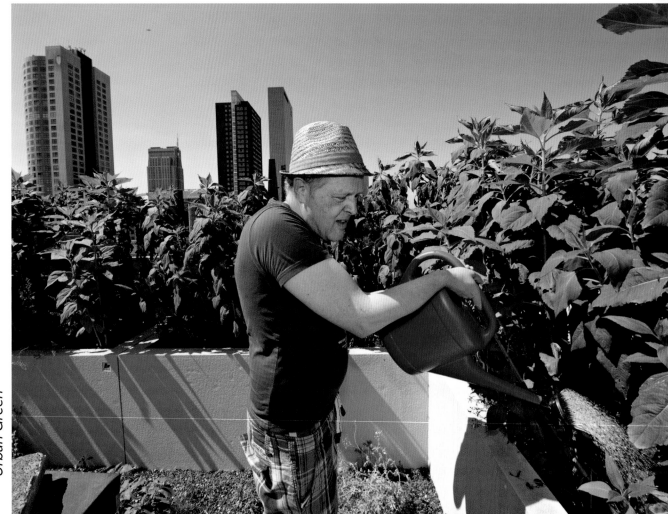

Urban Green

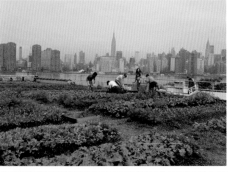

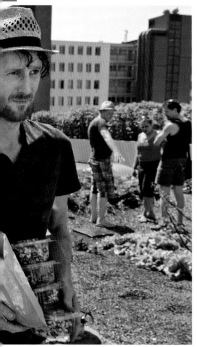
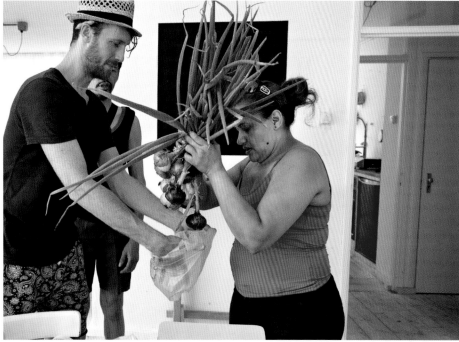

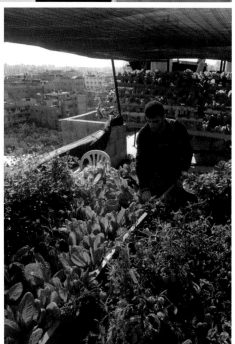
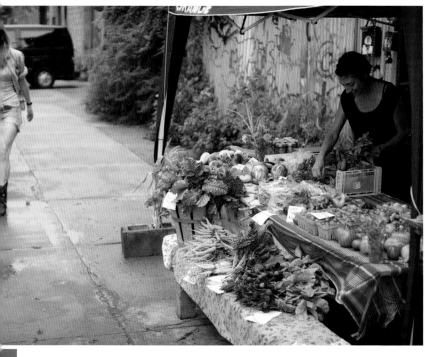
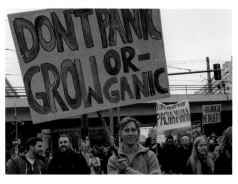

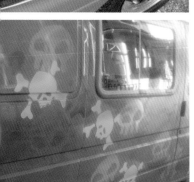

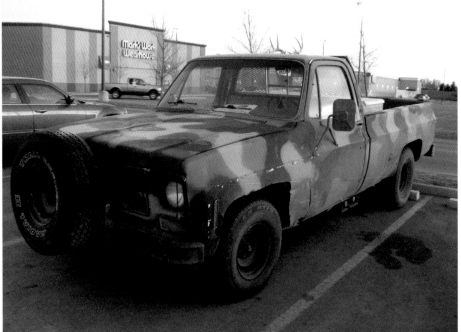

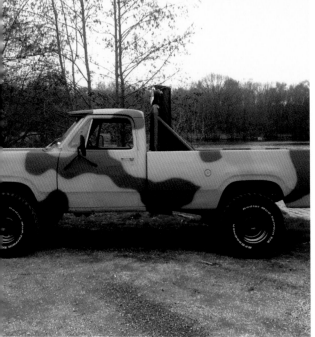

ALIEN

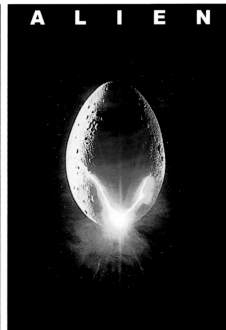

Monster Green

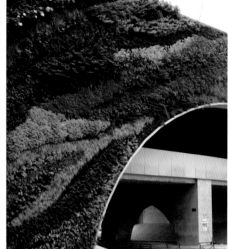

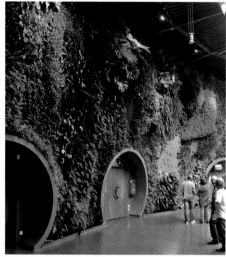

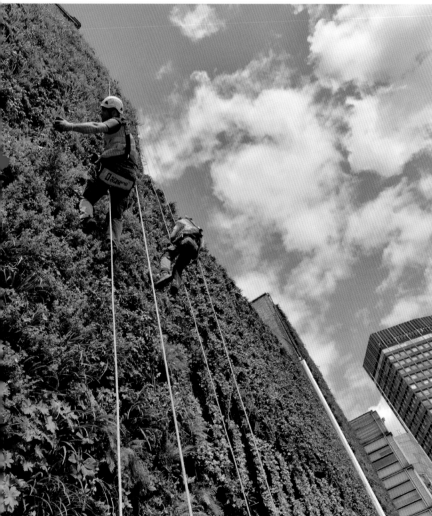

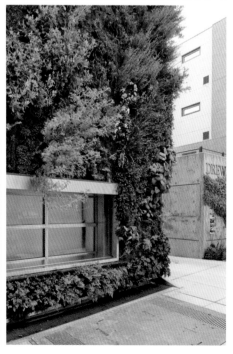

Taxicab Yellow
Chosen as the signal for Chicago taxis in 1915, coined in NY as the brand colour for any taxi system.

Cycling Yellow
The mother of all cycling events, Le Tour de France is synonymous with cycling and cycling culture.

Funny Yellow
Juvenile playfullnes in extra ordinary sizes.

Holy Yellow
Symbolising the golden key to the Kingdom of Heaven.

Creational Yellow
Activates nothing into something, the birth of all life and ideas.

Nuclear Yellow
Turning the sign for warning into a symbol for awareness.

Vincent Yellow
The equivalent for discovery in art: the universal symbol of individual belief.

Dutch Yellow
Manmade Holland: cheese, wooden shoes, flower fields, the national trains, Schiphol wayfinding system.

Illuminating Yellow
The yellow-skinned god Bodhisattva is a holy figure, reincarnated in the Dalai Lama and praised by its followers.

Taxicab Yellow

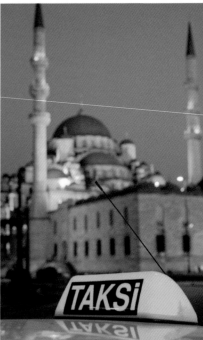

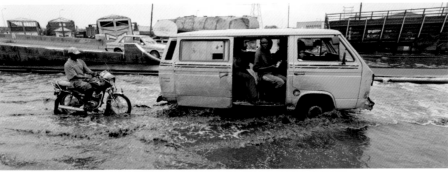

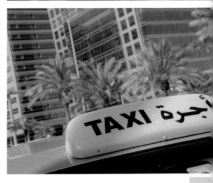

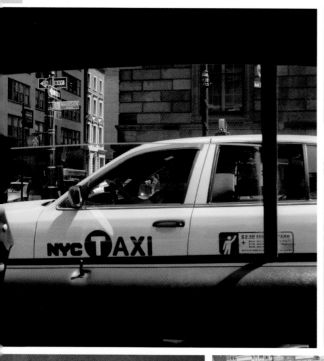
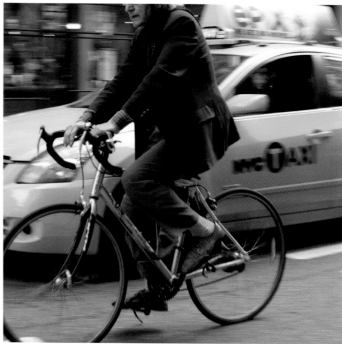

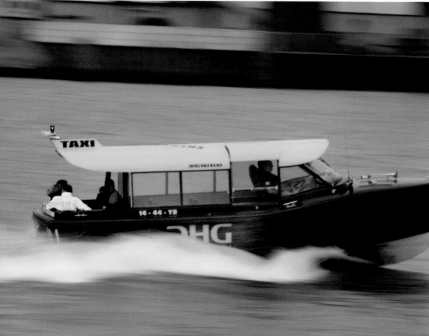

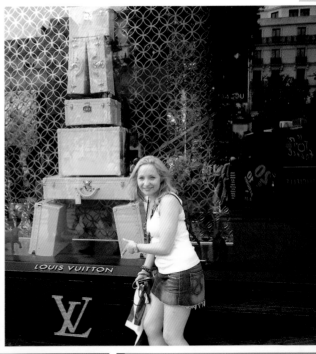

Cycling Yellow

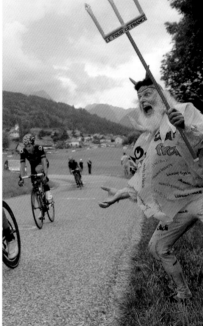

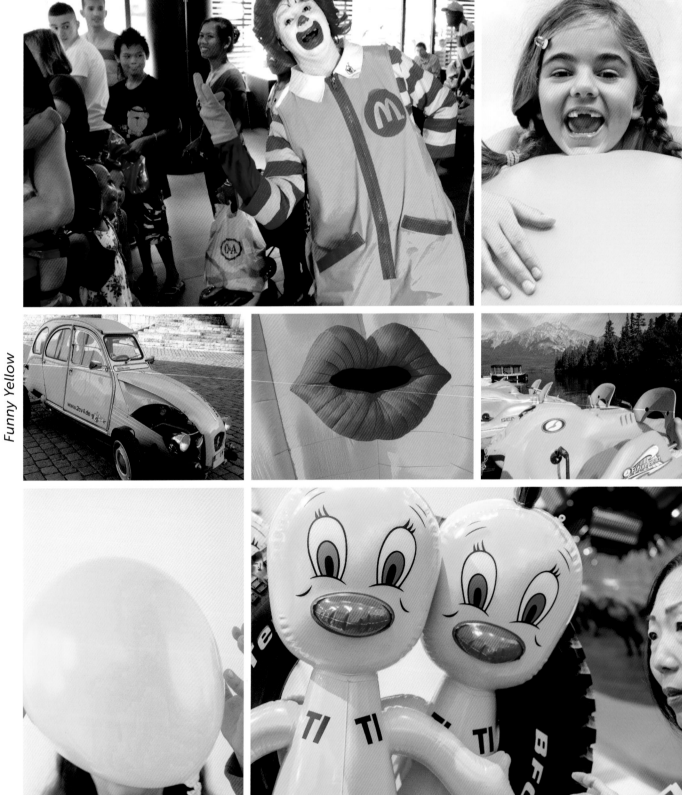

Funny Yellow

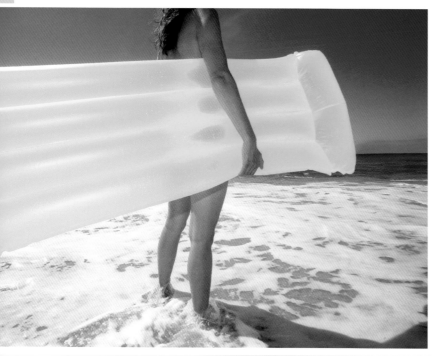

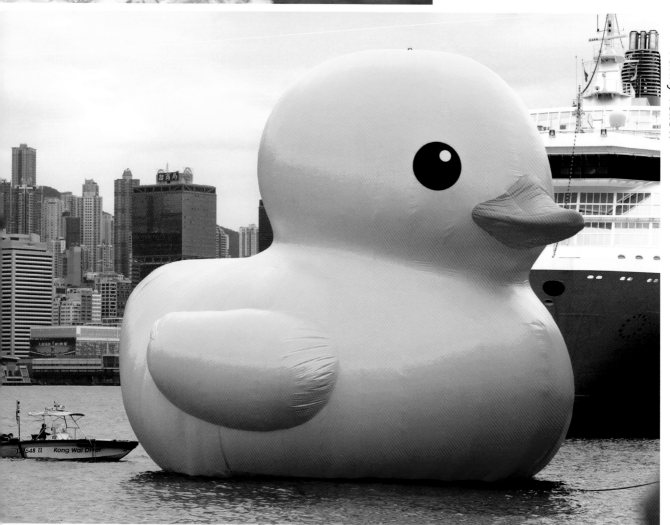

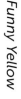

Holy Yellow

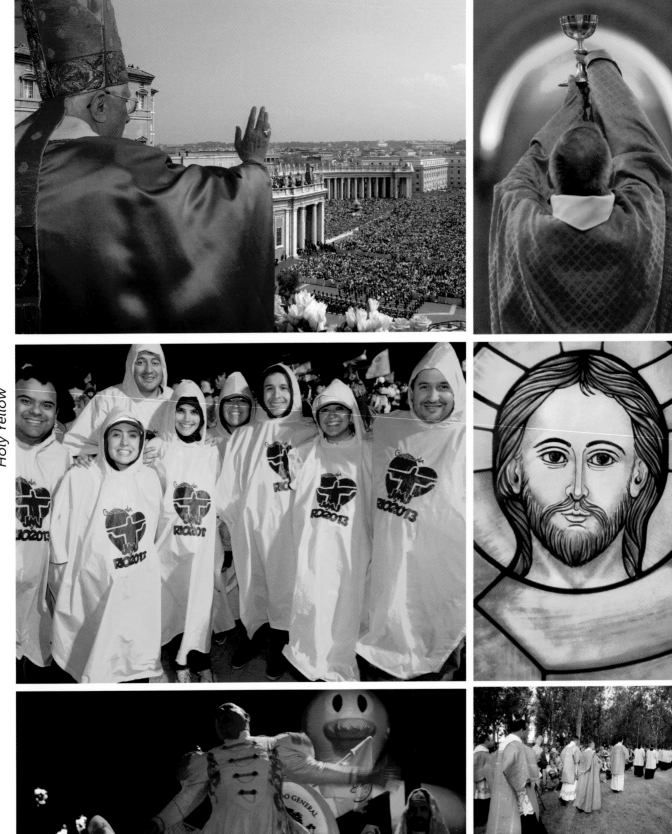

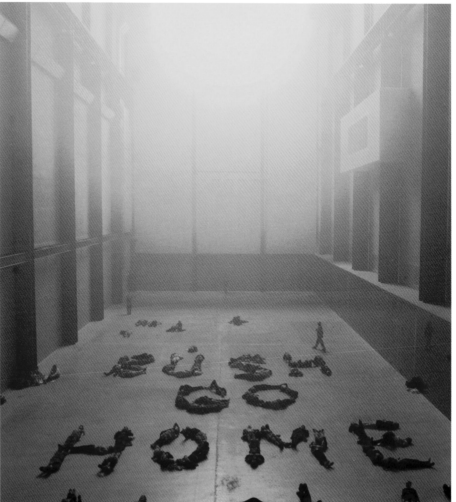

Little Sun

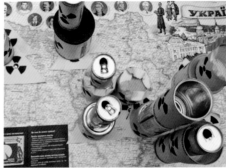

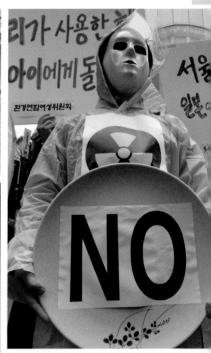

Nuclear Yellow

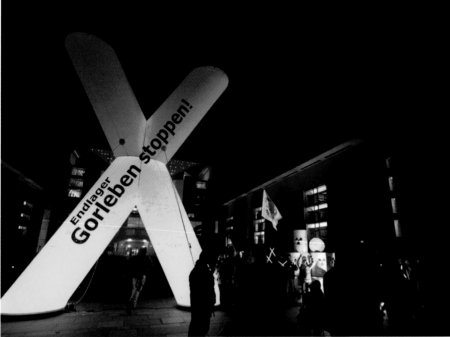

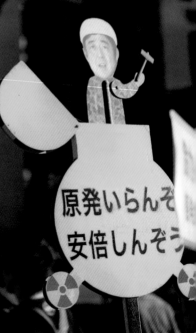

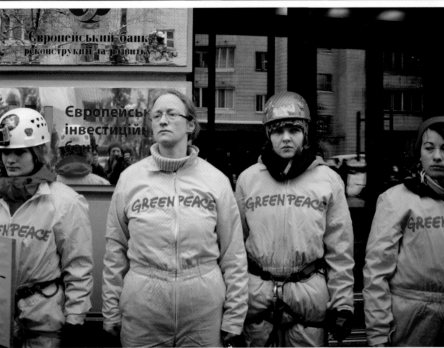

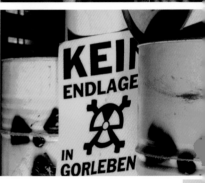

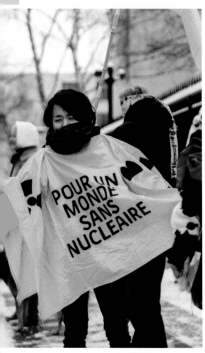

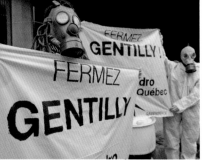

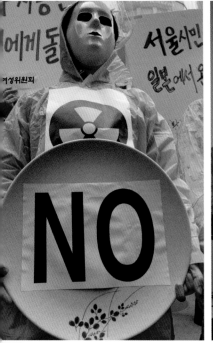

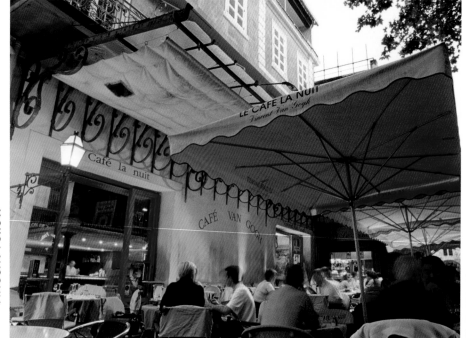

Vincent Yellow

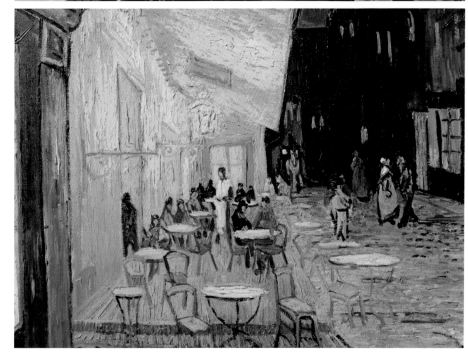

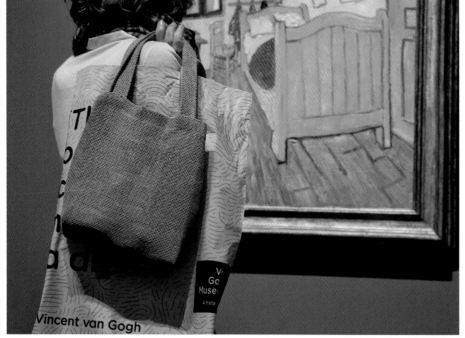

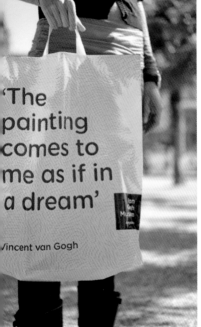

'The painting comes to me as if in a dream'

Vincent van Gogh

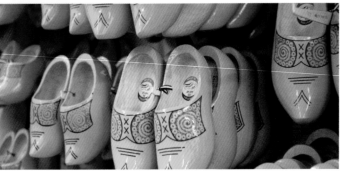

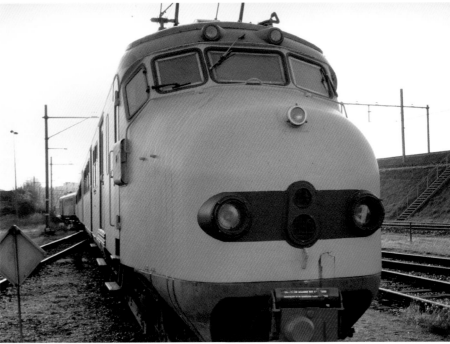

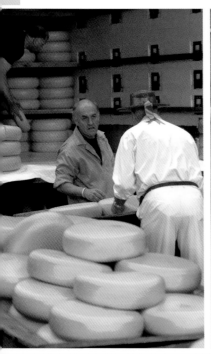

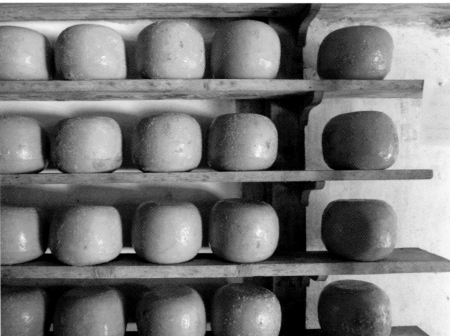

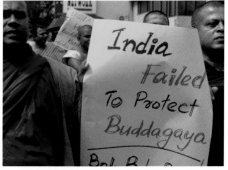

Illuminating Yellow

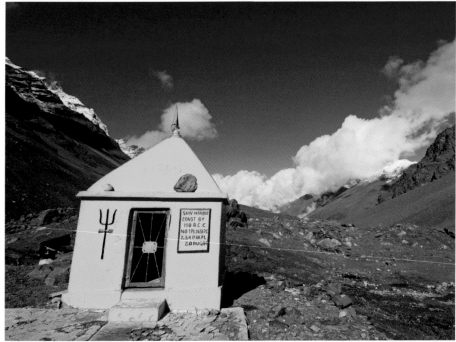

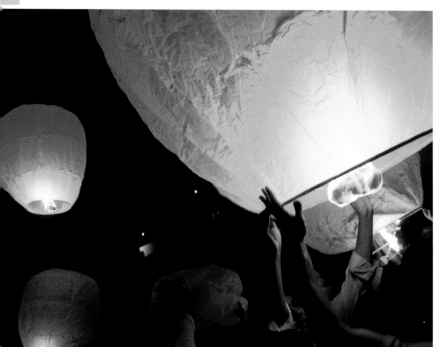

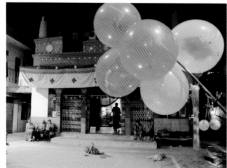

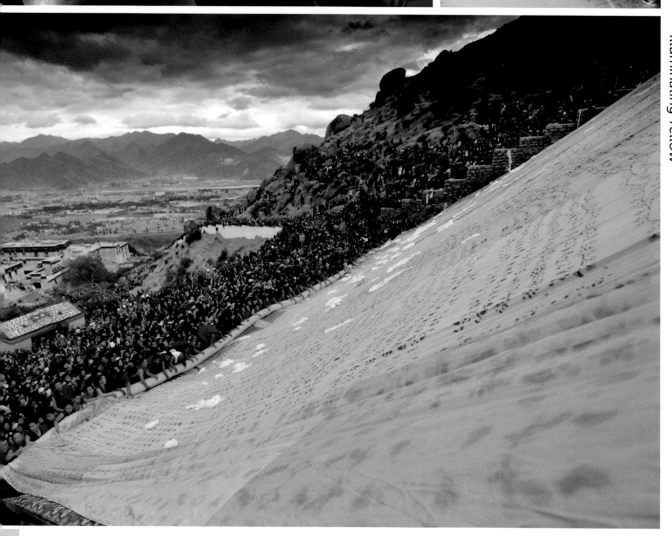

Silent White
Public dismay in the tradition
of Gandhi's peaceful protests.

Premium White
Tabula rasa is the new
premium. The rejection of all
decoration.

Pristine White
Innocent, fragile, pure.

Mourning White
Widespread in Asia, white
is the colour of mourning and
funerals.

Perfect White
Eternal value is expressed
when carved in marble.

Transparent White
A clear view of possessions,
ambitions and possibilities.

White Protest
Brazilian 2013 spring protests
against state financial policy
and police brutality.

White Dinner
Global flash-mob dinners
celebrating summer and
friendship.

Sensation White
Commemorating the death of
the party co-founder became
an event brand.

Arabian White
The most practical colour to
stay cool in the desert heat is
the sign for purity, peace and
prayer.

Silent White

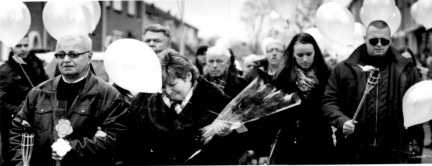

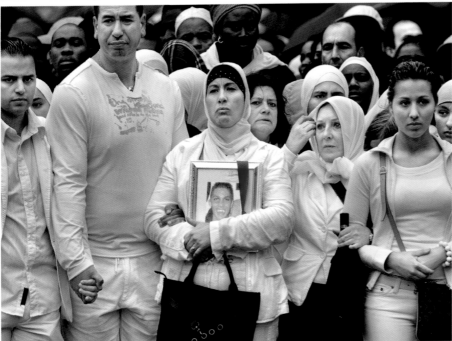

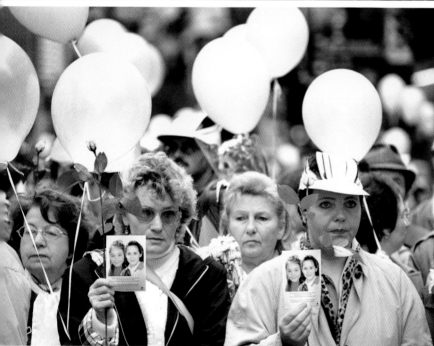

Premium White

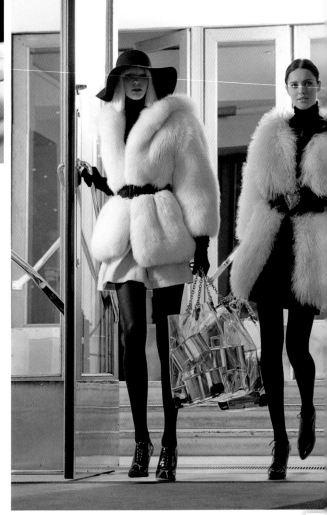

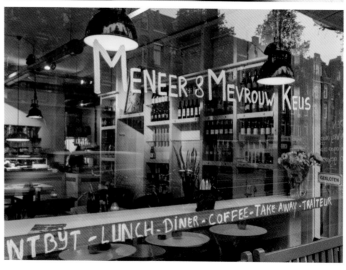

Pristine White

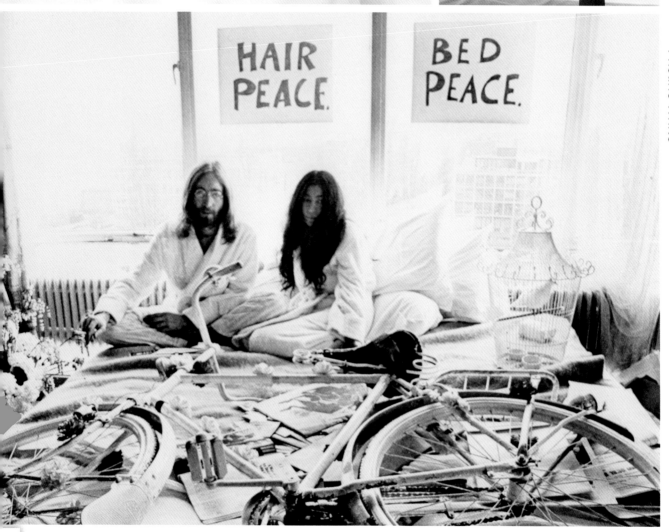

Mourning White

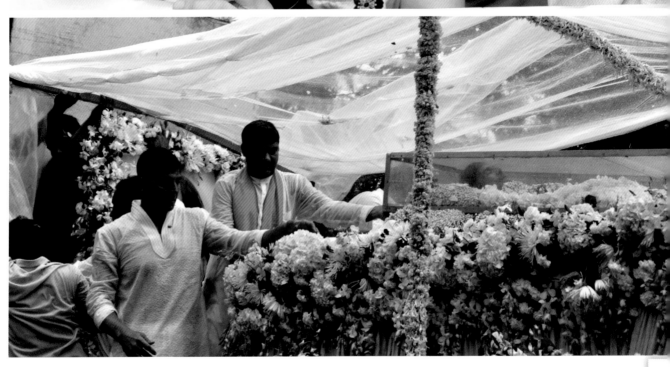

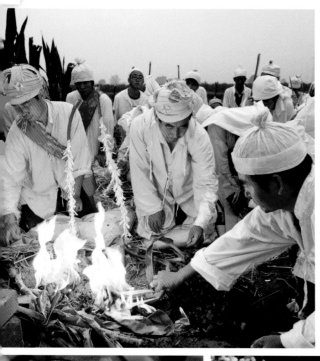

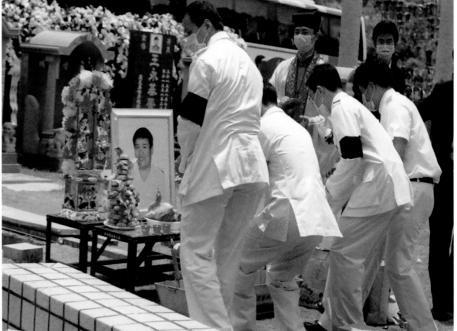
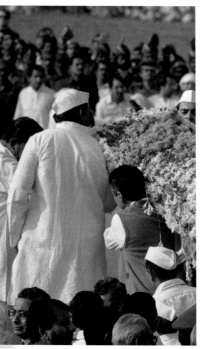

Perfect White

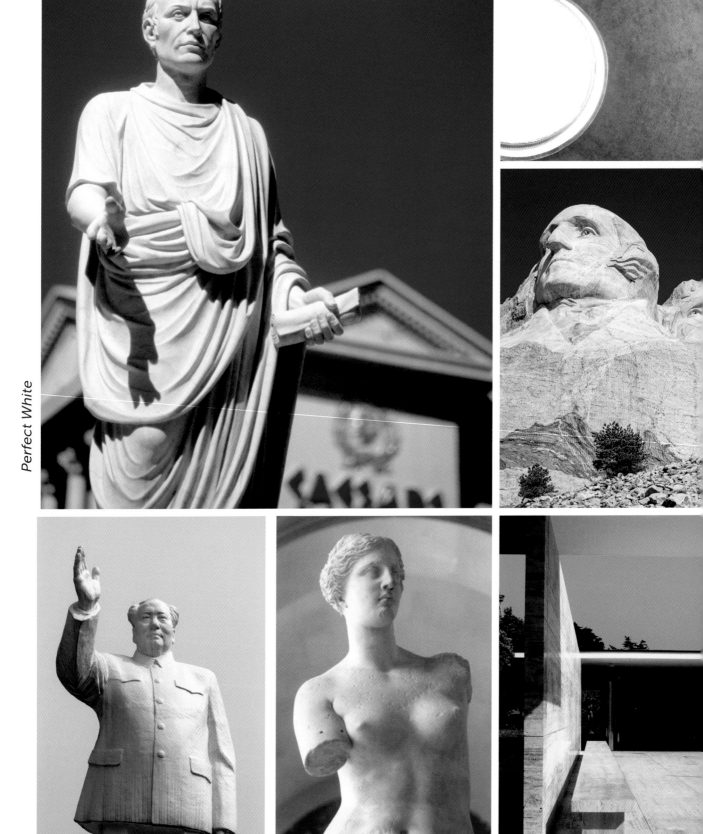

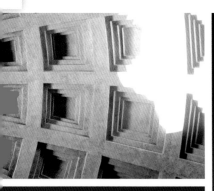

Transparent White

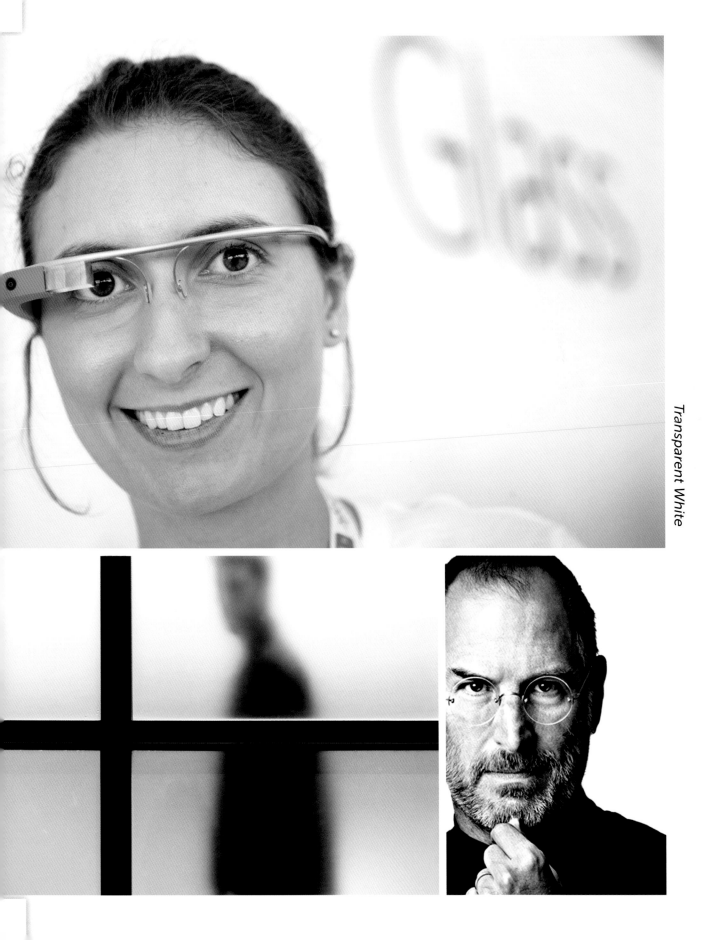

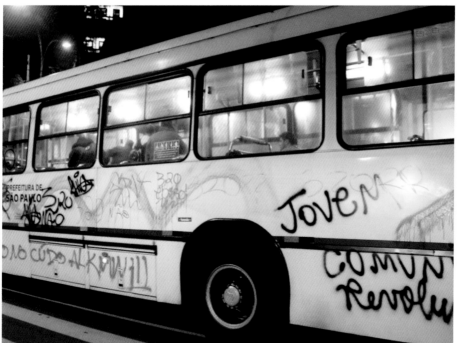

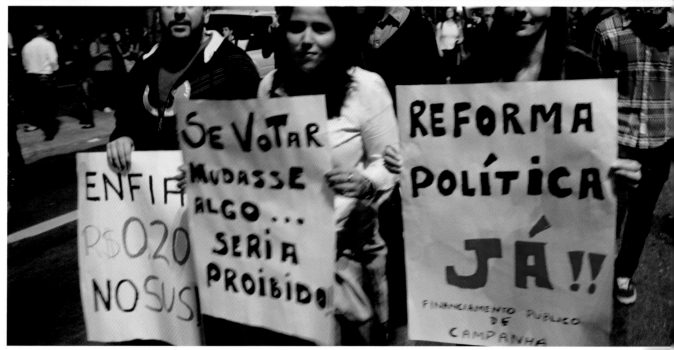

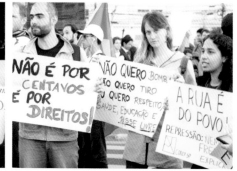

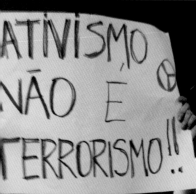

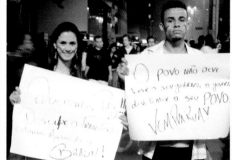

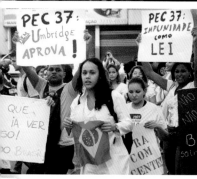

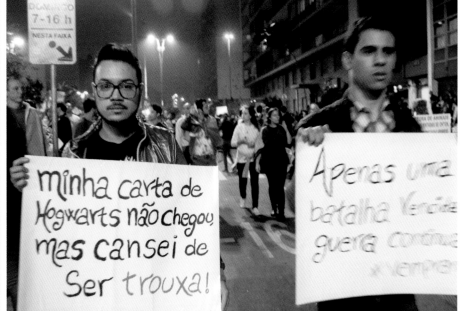

White Dinner

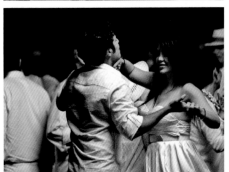

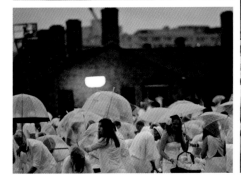

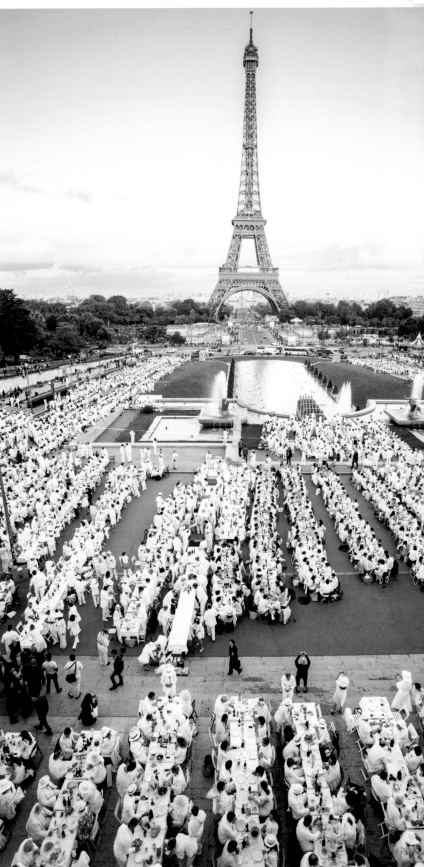

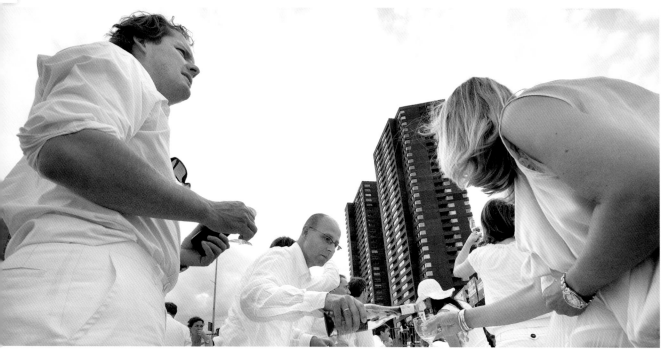

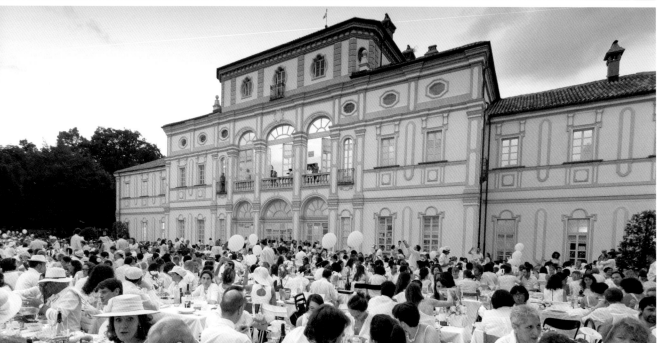

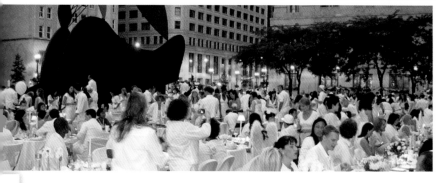

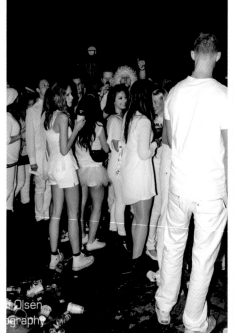

Sensation White

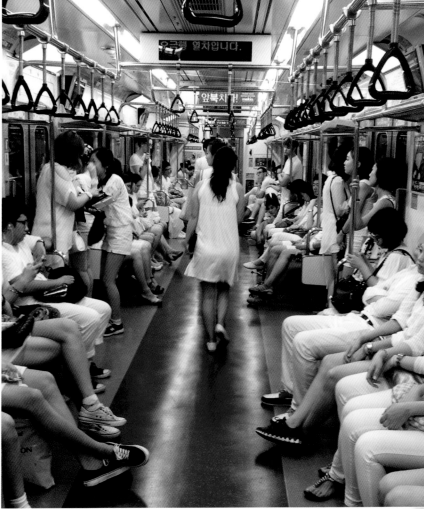

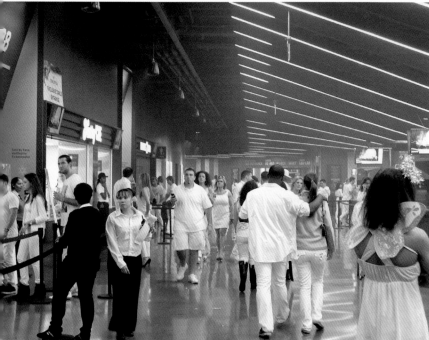

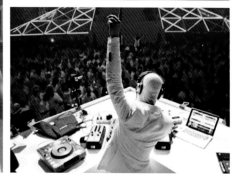

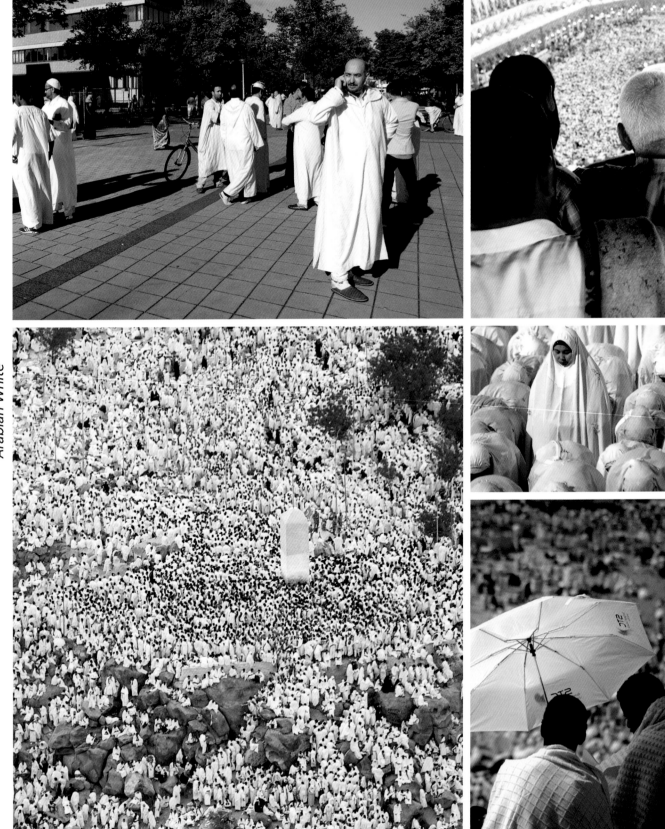

Arabian White

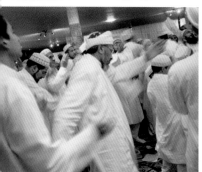
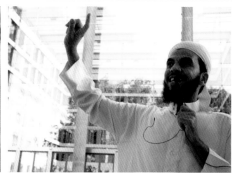

Ukrainian Orange
National colour used in the 2004
democratic revolution.

Dutch Orange
Taken from the Royal House of
Orange and adopted in large-scale
expressions of national identity.

Guantanamo Orange
Non-compliant captives'
jumpsuit uniforms.

Hindu Orange
The most sacred symbolic colour
in Hinduism, erasing impurities
through fire.

Buddhist Orange
The essence of wisdom,
strength and dignity.

Halloween Orange
On the Celtic calendar the day allowing
room for play between the last and
first day of new calendar.

Irish Orange
The colour of Protestants in Northern
Ireland whose identity is connected to
King William of England.

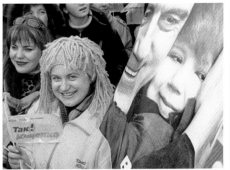

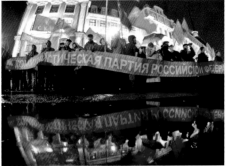

Ukrainian Orange

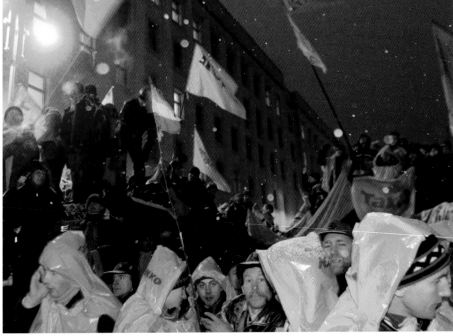

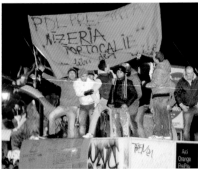

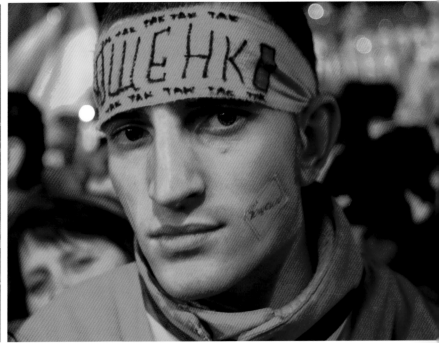

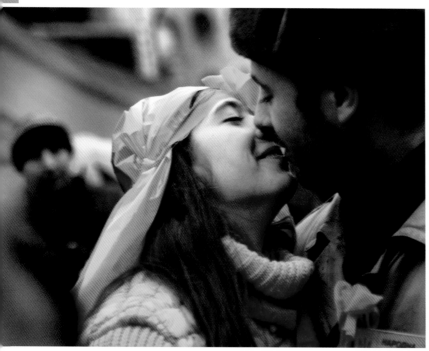
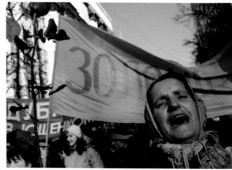

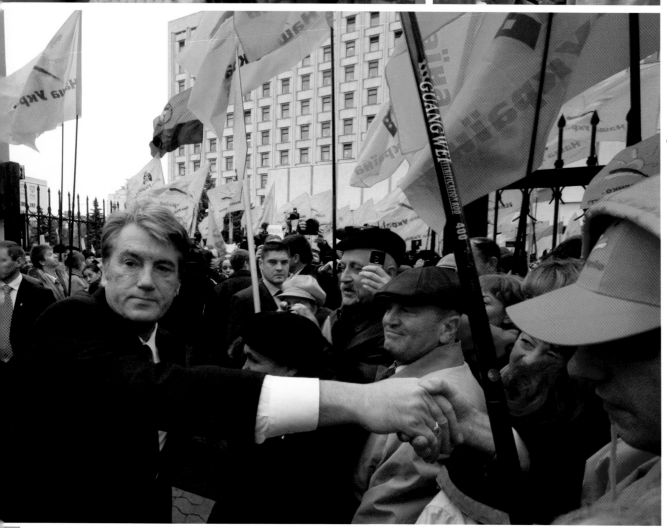

Dutch Orange

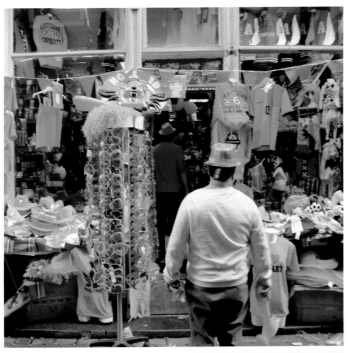
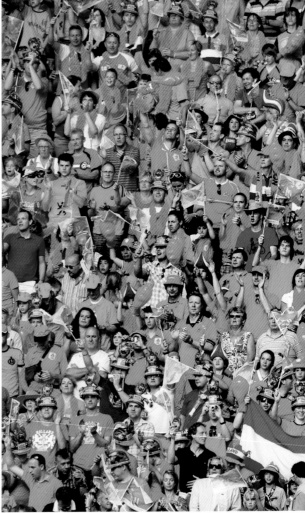

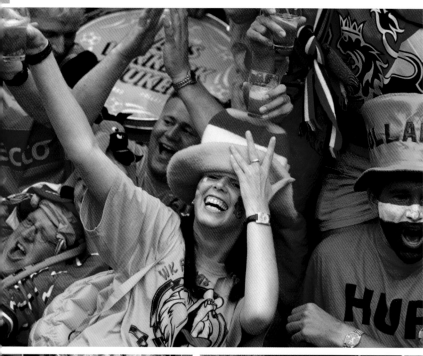

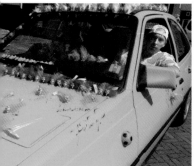

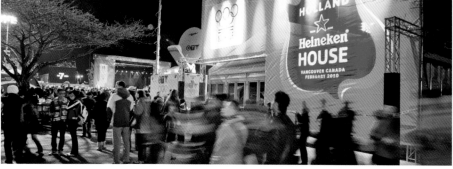

Guantanamo Orange

IF THE FIRST CASUALTY
OF WAR IS
TRUTH
THE NEXT IS
HUMAN RIGHTS

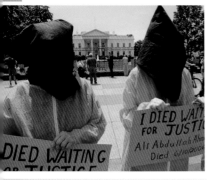
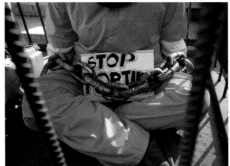
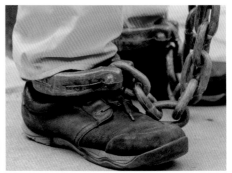
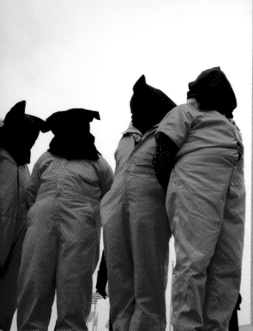
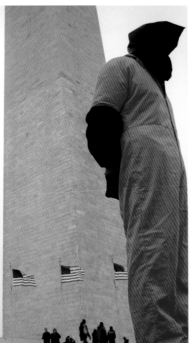
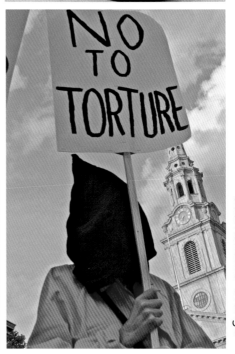

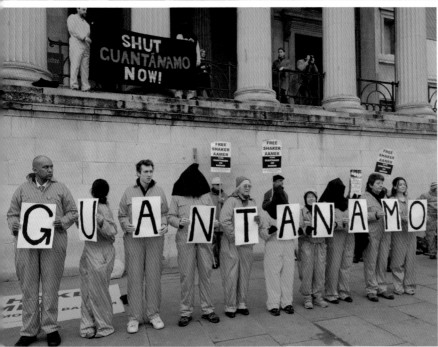
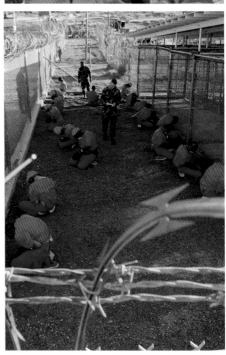

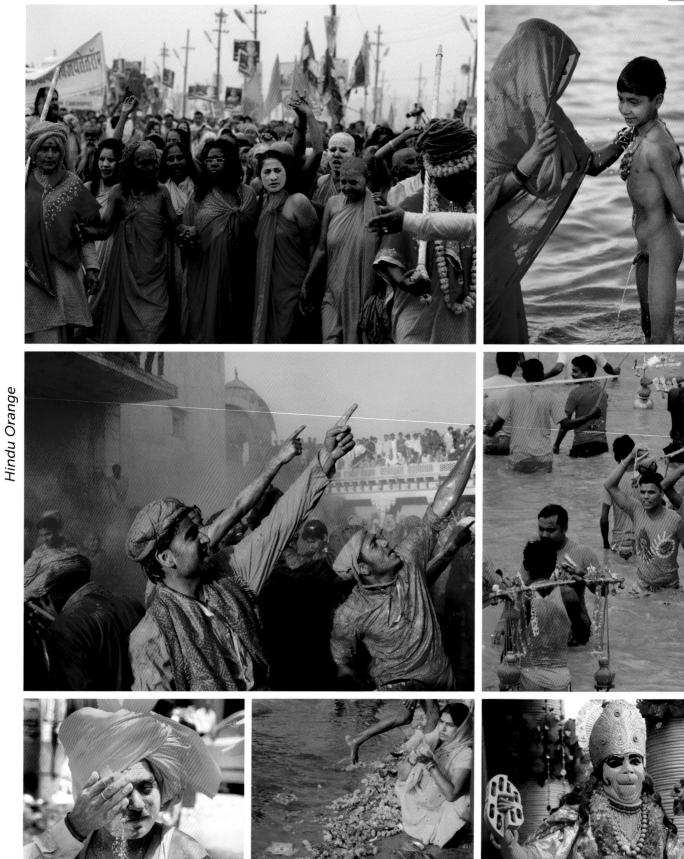

Hindu Orange

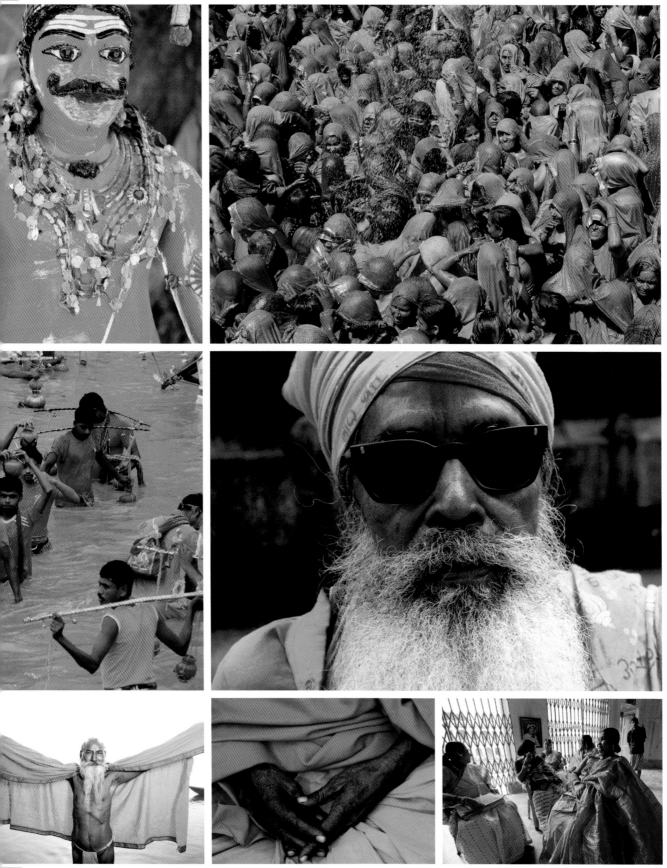

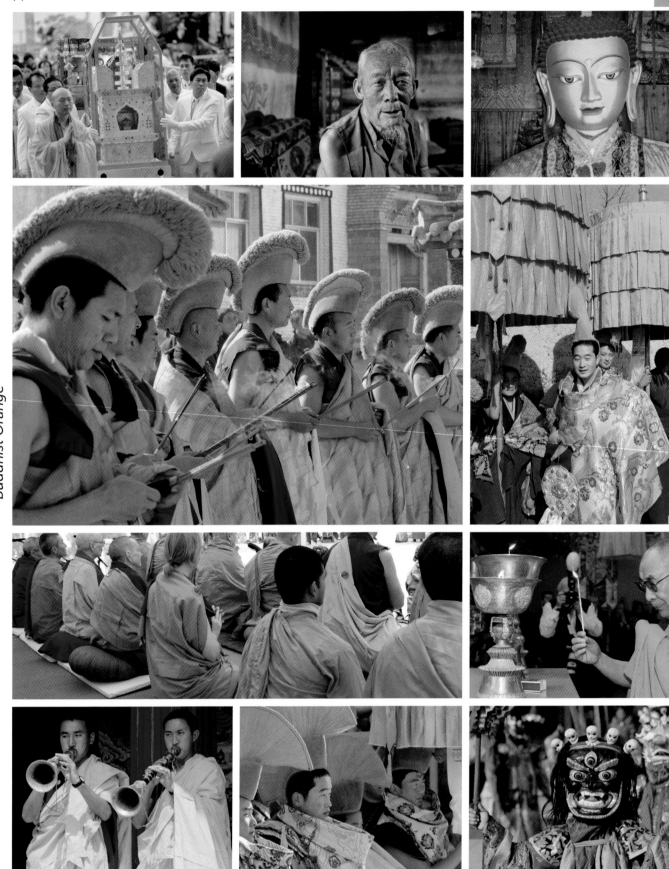

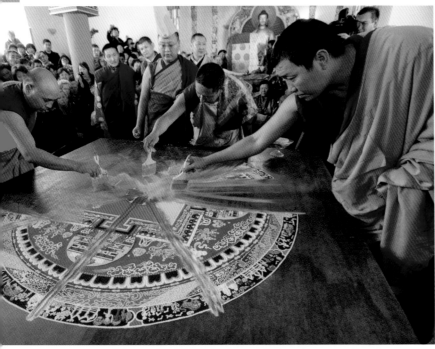

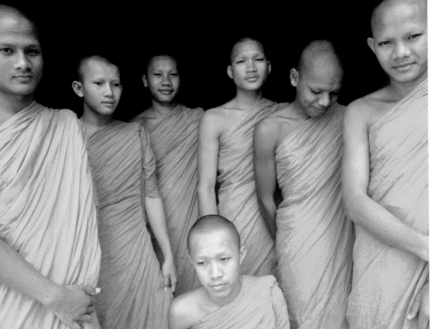

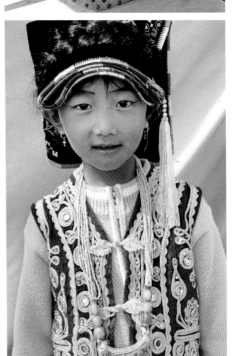

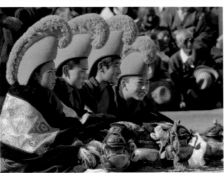

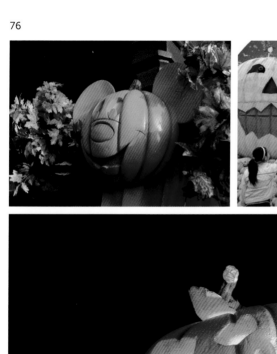

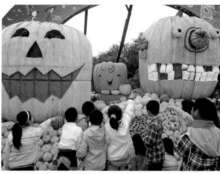

Halloween Orange

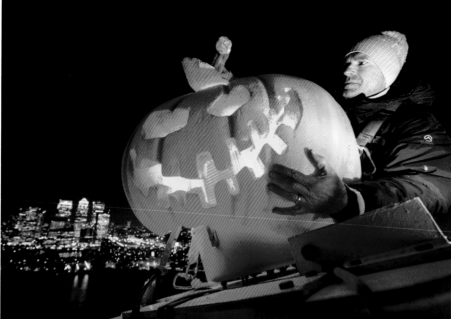

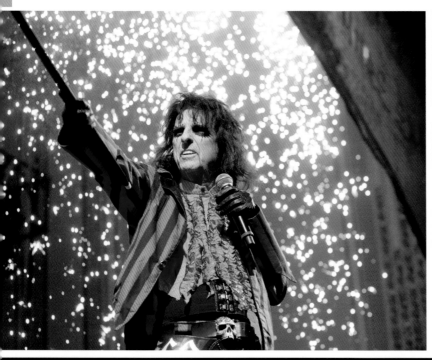

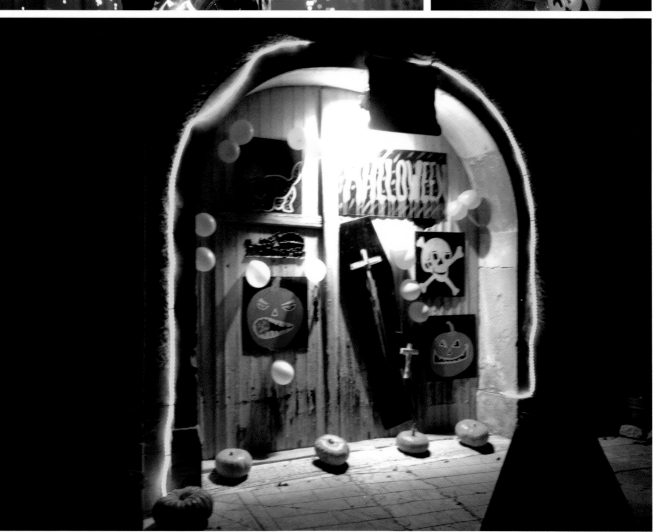

Irish Orange

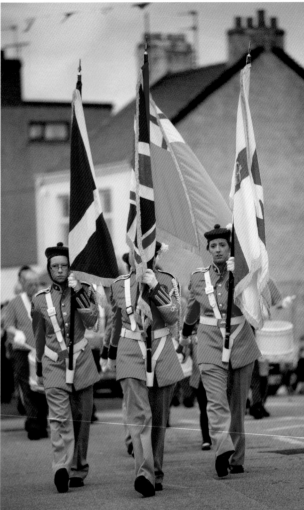

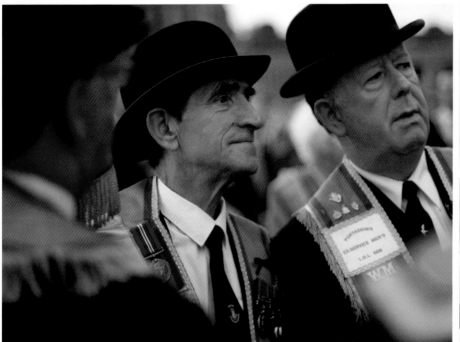

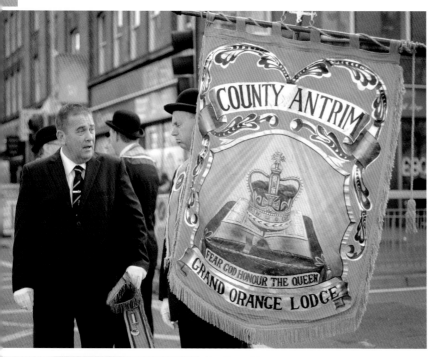

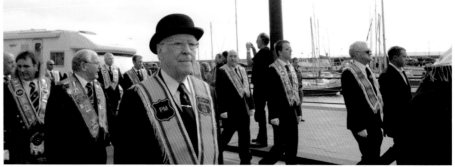

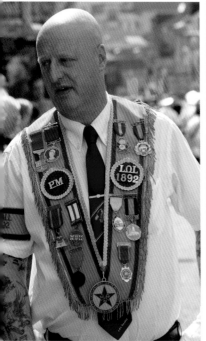

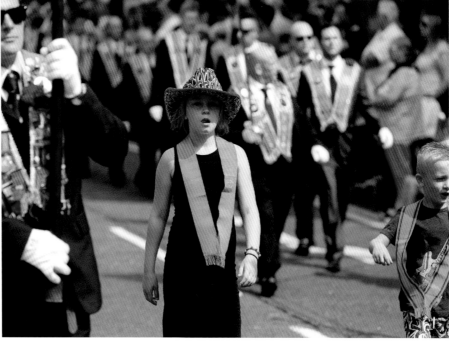

Irish Orange

Rainbow Pride

Symbolising diversity in the gay community, it originated in 1978 San Francisco Gay protests.

Whipals Rainbow

7 x 7 coloured motif expressing the identity of Andes and Bolivian Indians.

Buddhist Rainbow

Expressing the Buddhists' innermost feelings.

Kumbha Mela Rainbow

Bonding with others without discrimination based on caste, creed or colour.

Rainbow Rave

Ecstasy and techno music, part of 90s rave culture.

Carnival Rainbow

Red-Yellow-Green South Netherlands and German Ruhr area.

Rainbow Pace

Originated as a Catholic campaign in Italy and Switzerland against the 2002 Iraq War.

Rainbow Pride

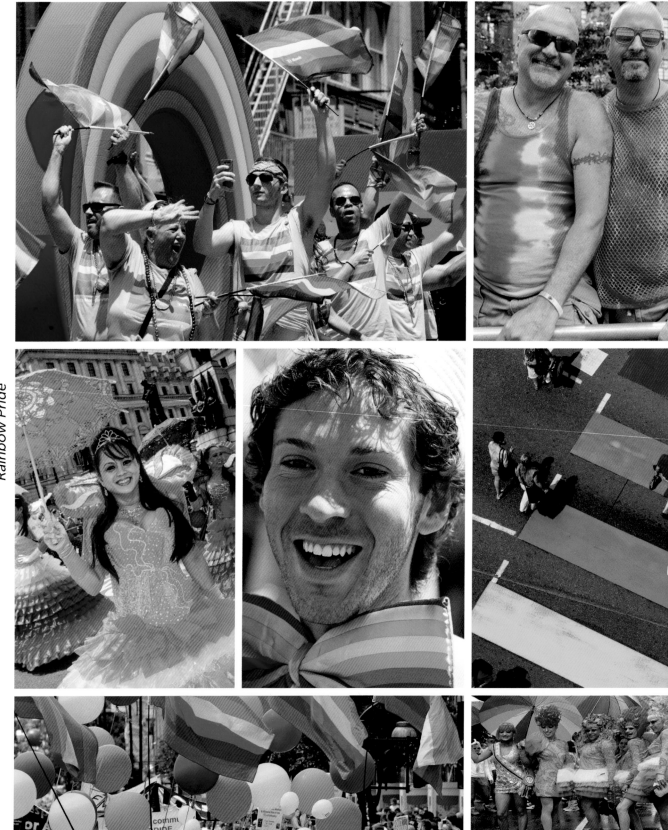

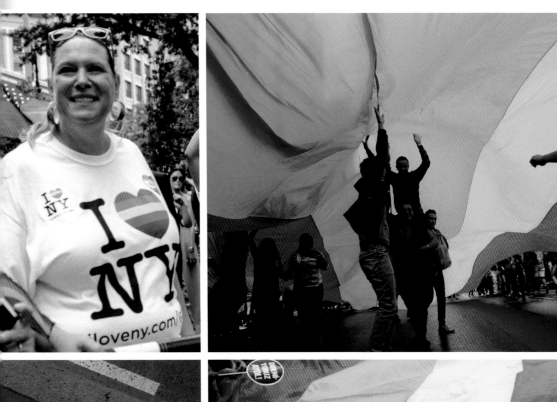
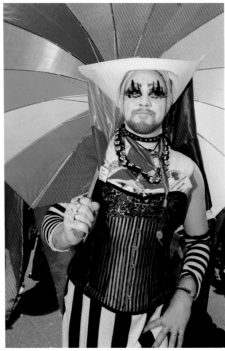
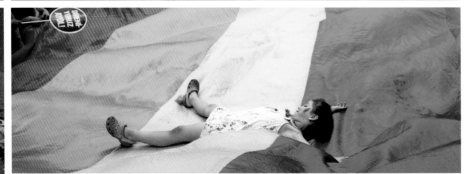

Rainbow Whipals

SUR-AMÉ-RICA
NATH.

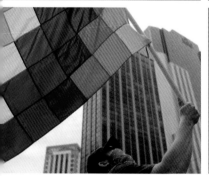

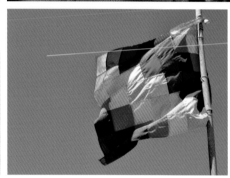

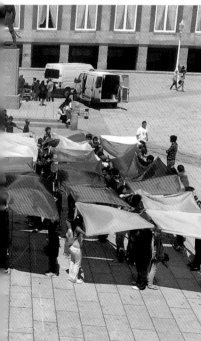

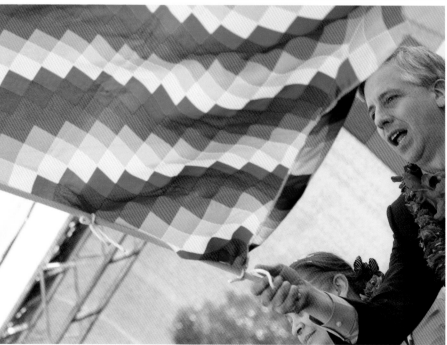

Buddhist Rainbow

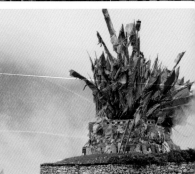

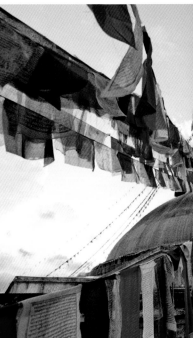

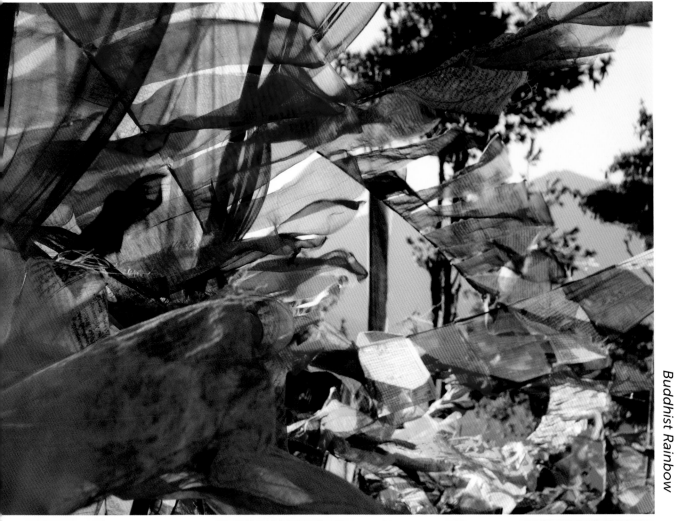

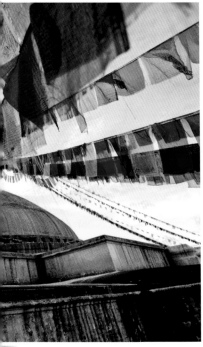

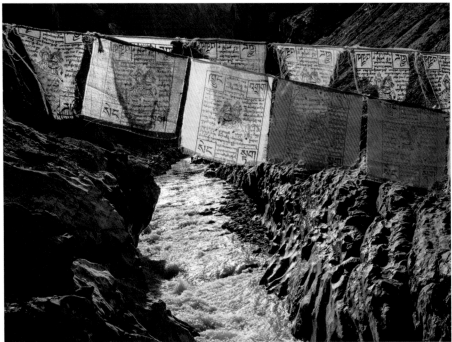

Kumbha Mela Rainbow

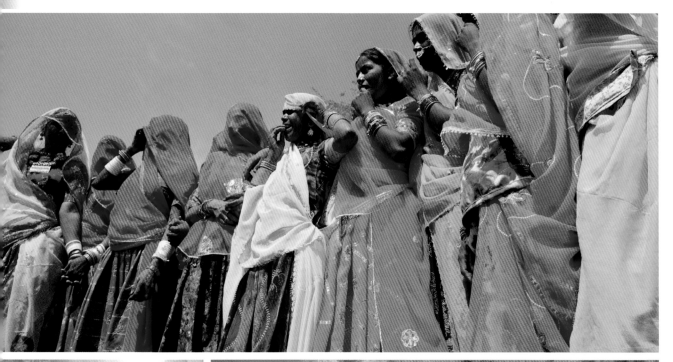

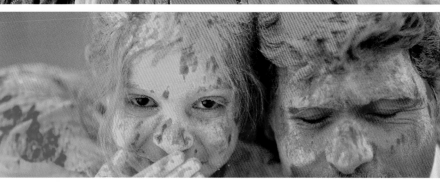

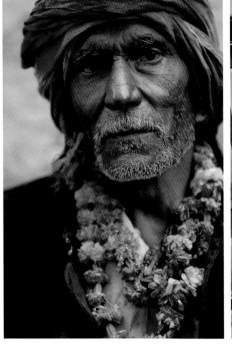
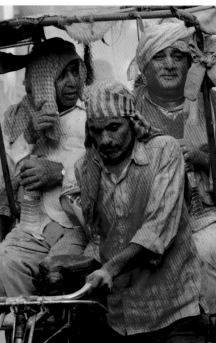

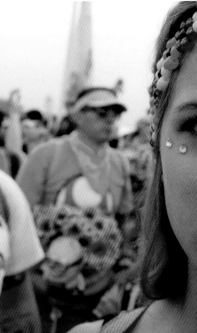

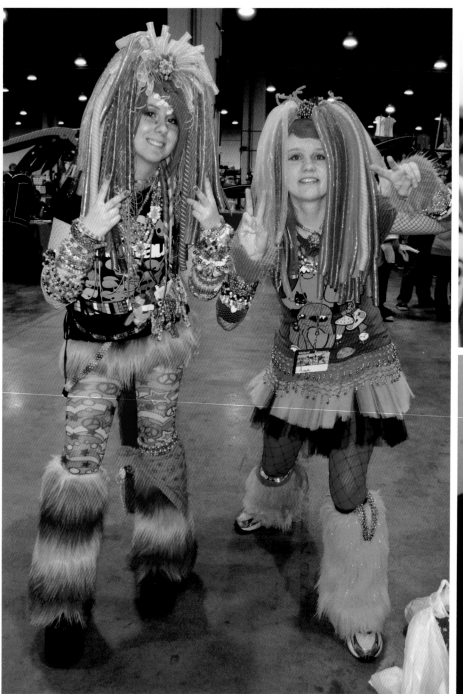

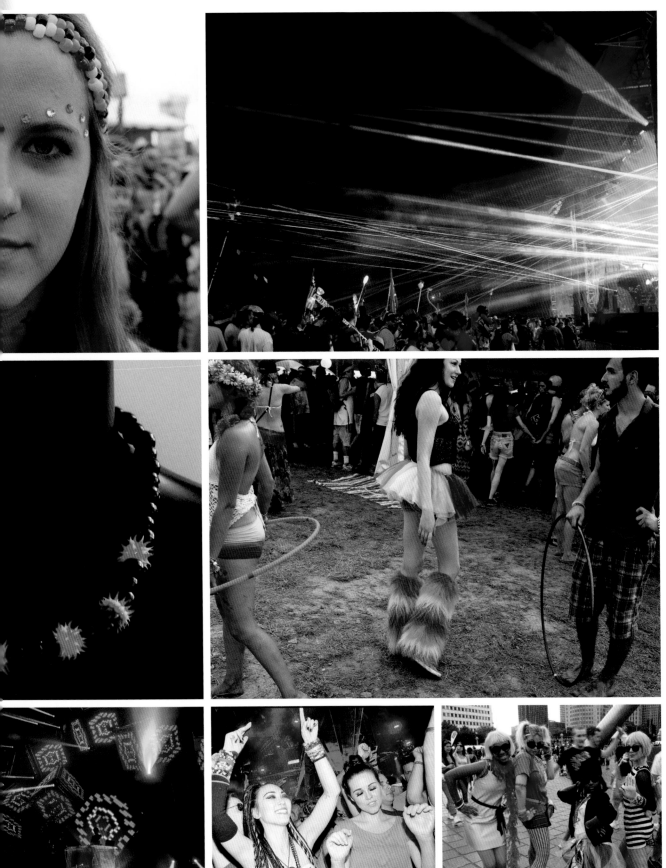

Carnival Rainbow

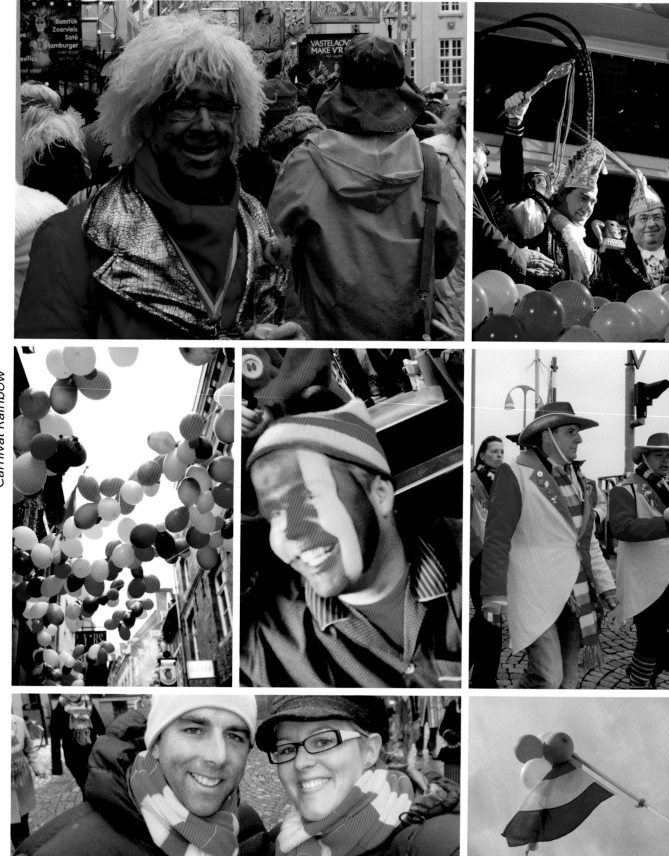

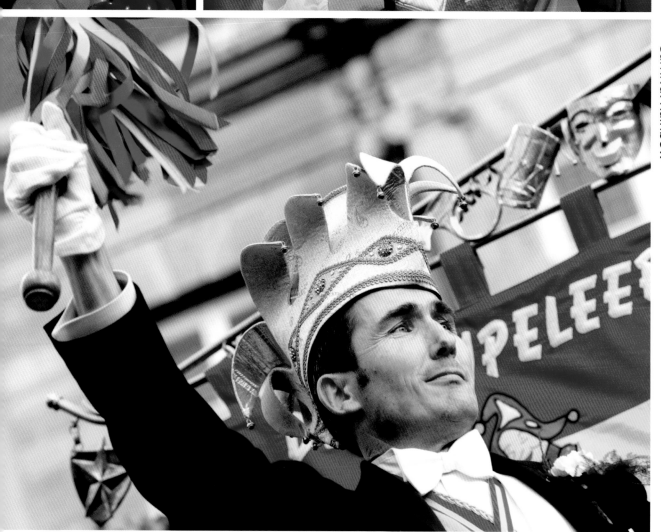

Rainbow Pace

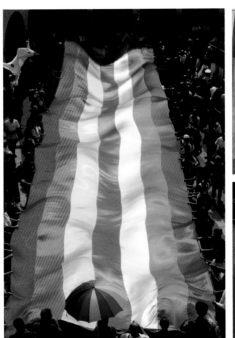

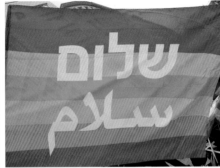

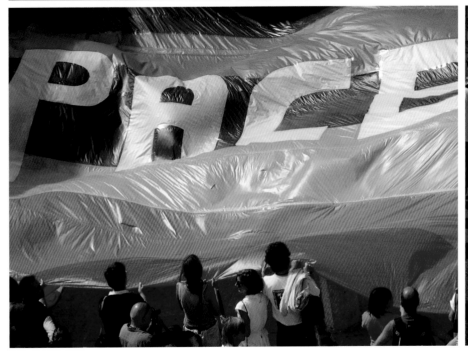

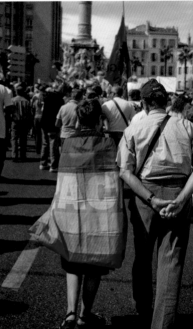

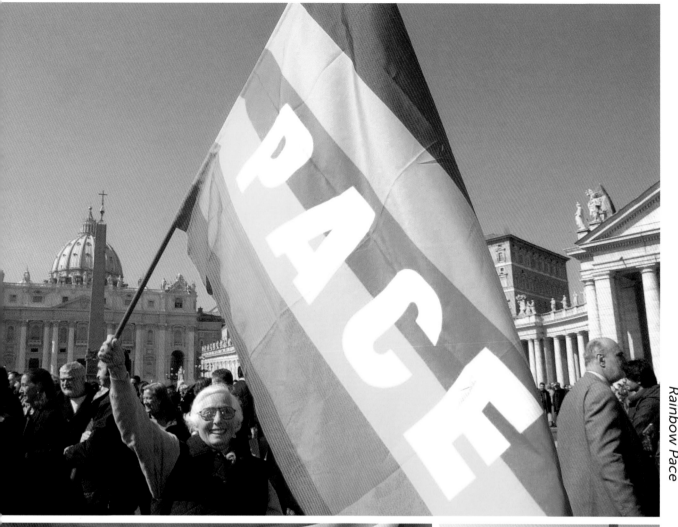

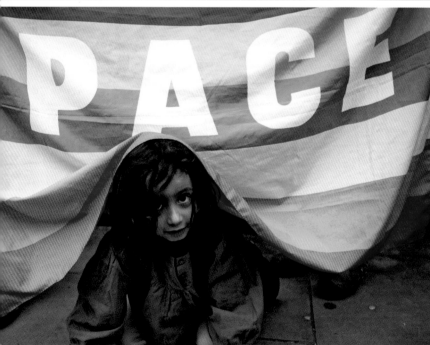

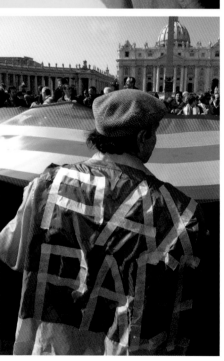

Basque Red
Token for cultural autonomy, folklore meets politics.

Protest Red
The template for all protests originated in communism.

Democratic Red
The Labour red rose is the basis for social democratic communication.

Supporting Red
Popular Burmese pro-democracy protests.

Cedar Red
The symbol of liberating Lebanon from Syrian hegemony.

Lucky Red
The symbol for good fortune and joy, found everywhere during Chinese New Year.

Ceremonial Red
Ceremonies and ritual celebrations communicating sovereignty.

First of May Red
Fusion of reactionary, communistic and anti-fascist groups.

Attractive Red
Full of contrast, attention, associated with courage and passion.

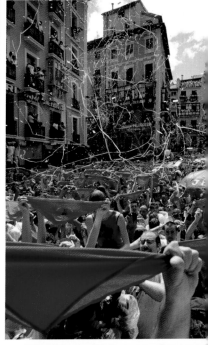

Basque Red

Protest Red

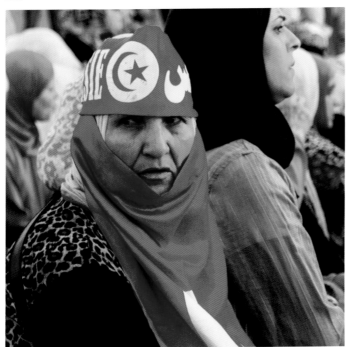

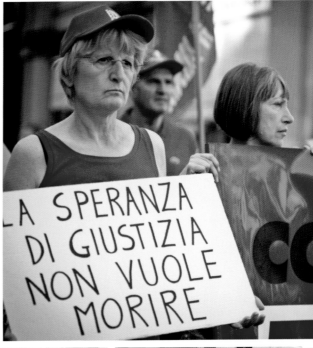

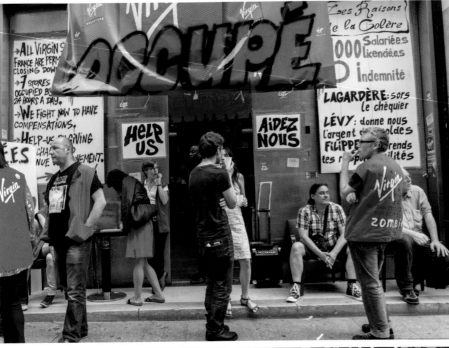

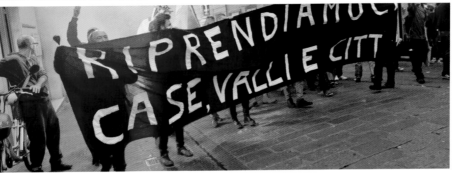

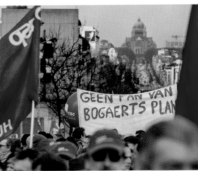

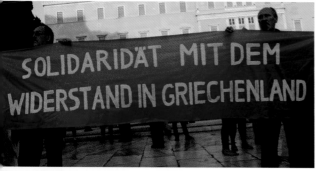

SOLIDARIDÄT MIT DEM WIDERSTAND IN GRIECHENLAND

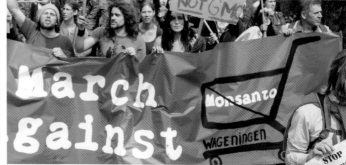

March against Monsanto WAGENINGEN STOP

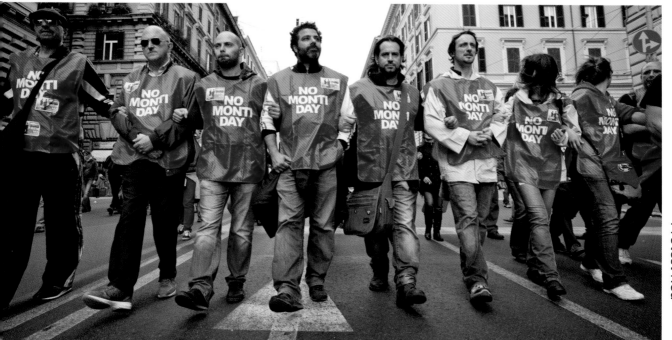

NO MONTI DAY

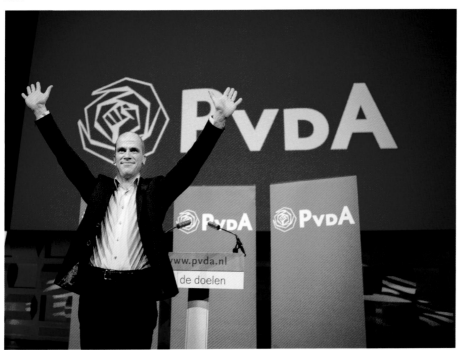

Democratic Red

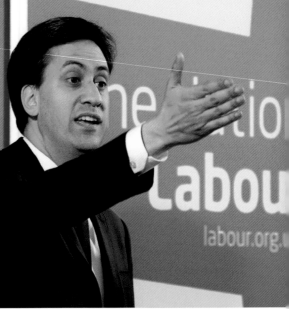

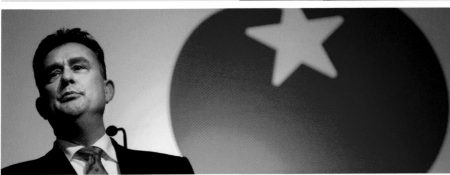

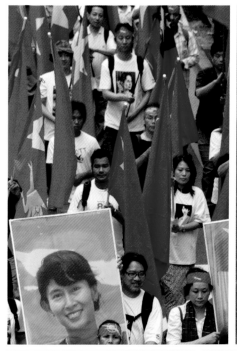

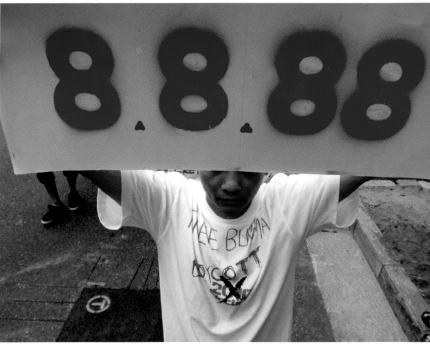

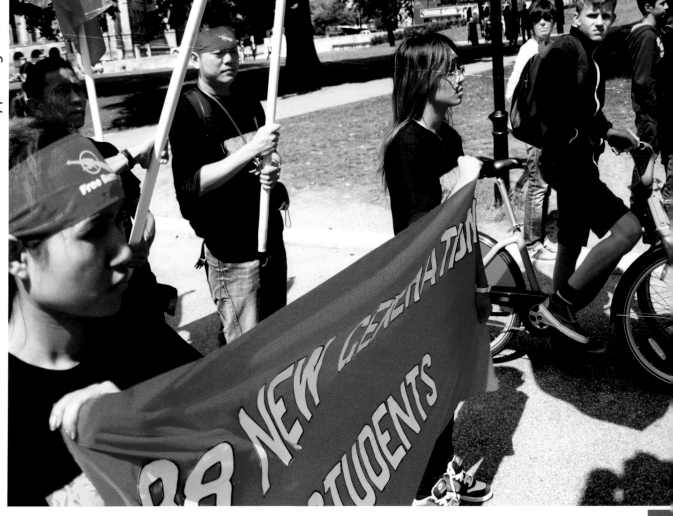

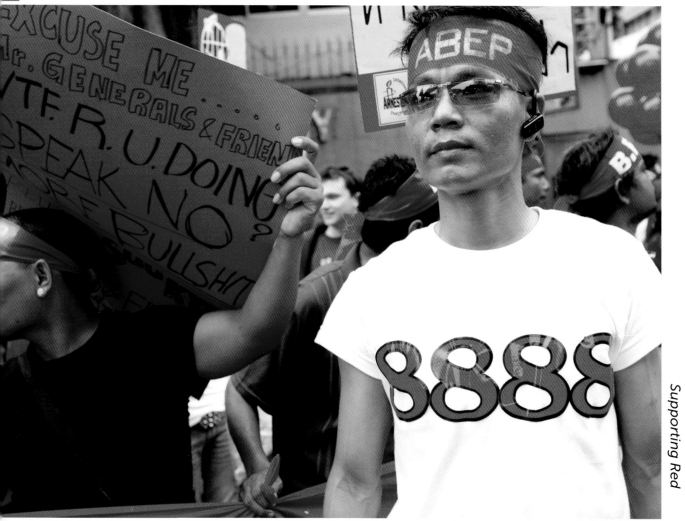

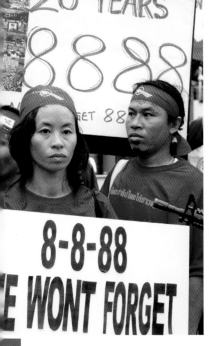

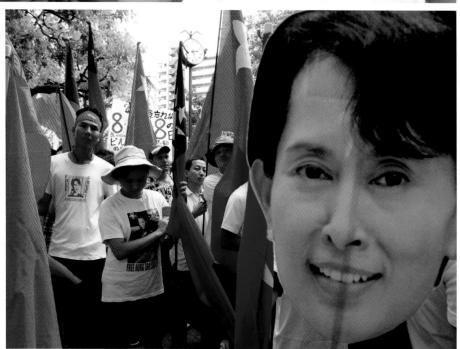

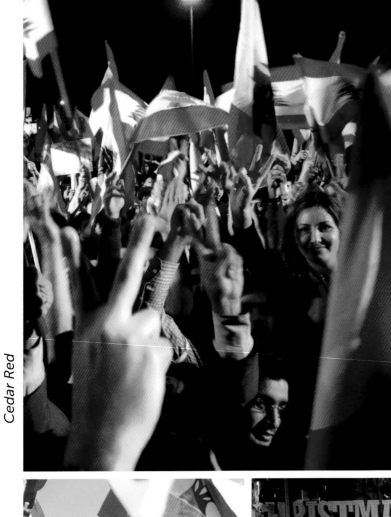

Cedar Red

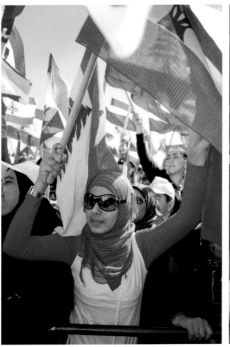

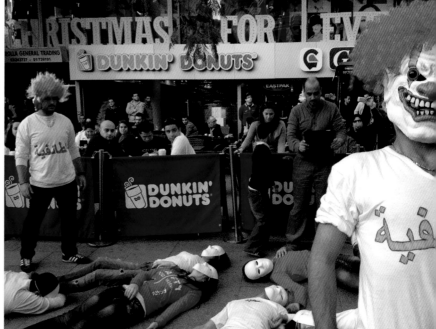

Lucky Red

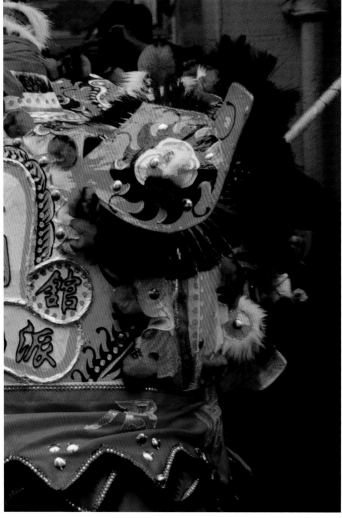

Ceremonial Red

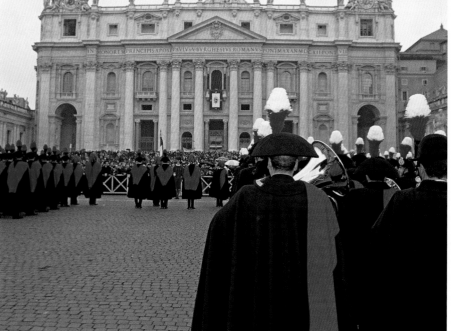

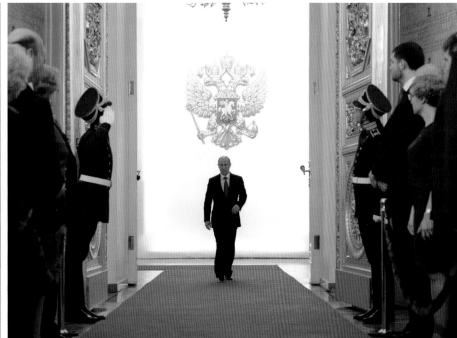
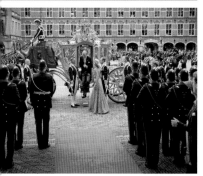
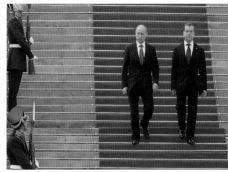
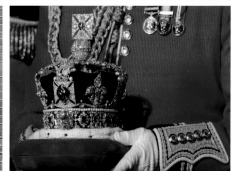
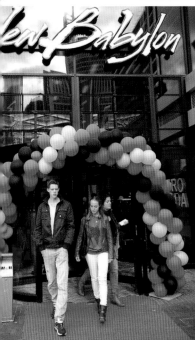
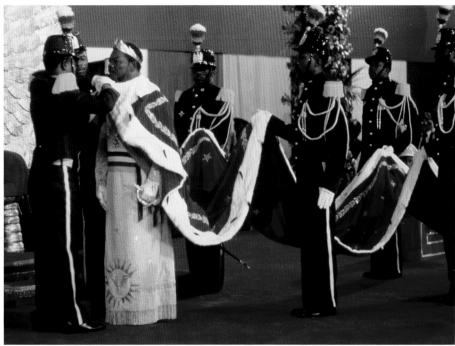

First of May Red

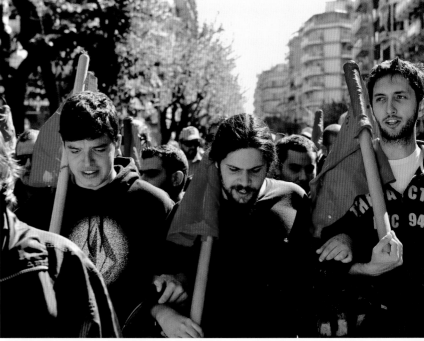

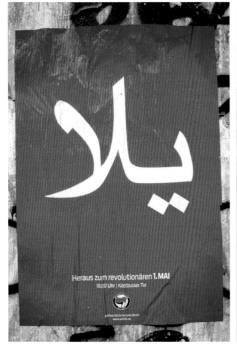

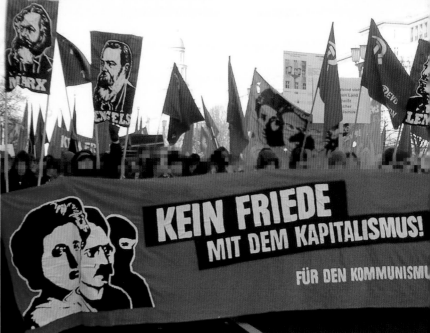

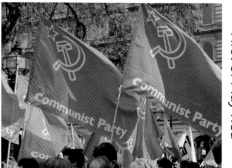

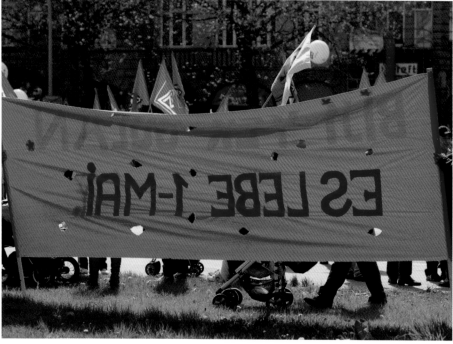

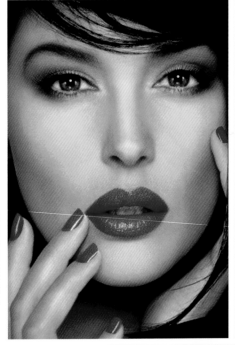

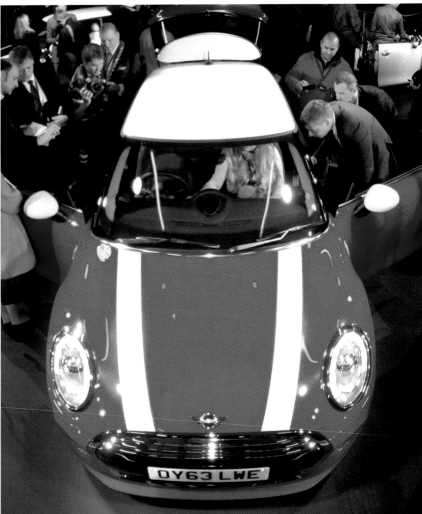

Attractive Red

Marketing Pink

Flash of attention, value-free, high-contrast communication on black-and-white backgrounds.

Girly Pink

A 20th-century invention to split gender into a blue (boys) and pink world.

Gay Pink

Pink was the colour used by the Nazis to brand gays with a triangle.

Harajuku Pink

Gothic Lolita style seen around Harajuku station in Tokyo, mixing Lolita and gothic style.

Lolita Pink

The tempting offer of the innocent girl from Nabokov's novel.

Pink Concern

The Pink Ribbon movement expresses world-wide concerns on breast cancer awareness.

Pop Pink

Originated in the PopArt movement, associated with 1960s hippies and freedom.

118

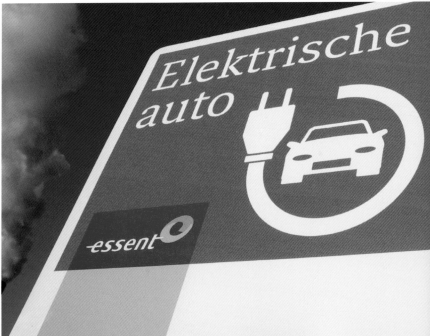

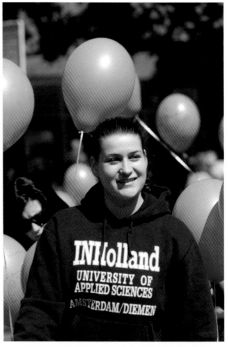

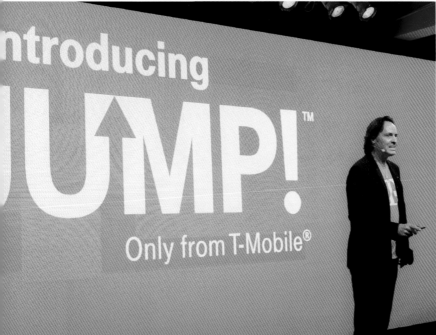

Girly Pink

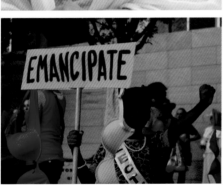

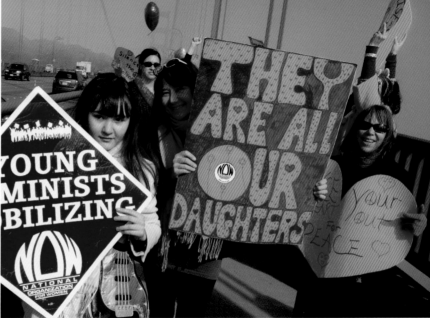

Gay Pink

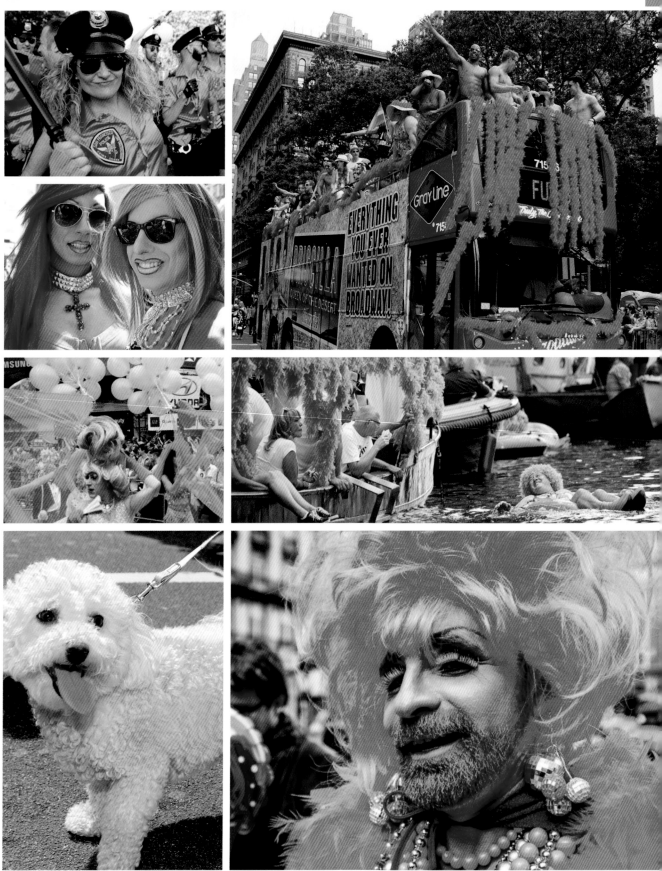

IGUALDAD INTERNACIONAL
DE DERECHOS

Unión
Progreso y
Democracia

LESBIMOEDER
JA NEE

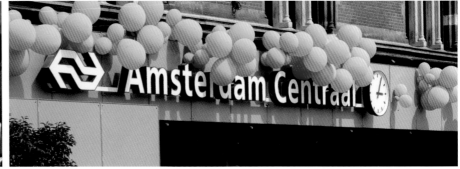

Amsterdam Centraal

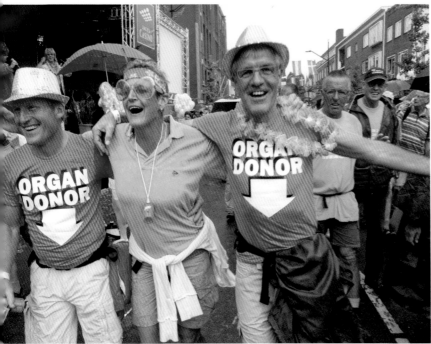

ORGAN DONOR

ORGAN DONOR

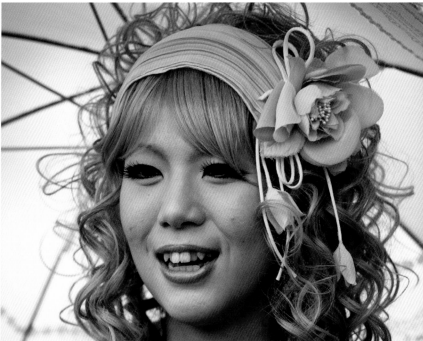

Harajuku Pink

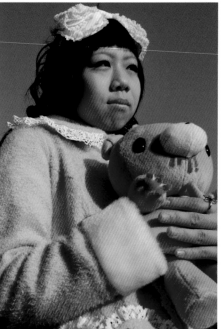

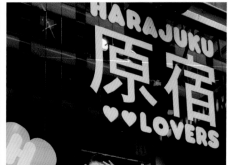

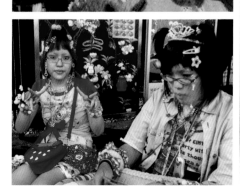

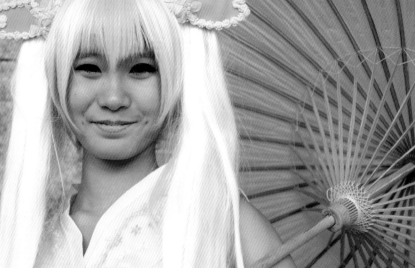

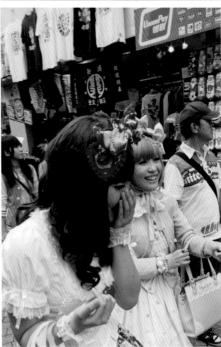

Lolita Pink

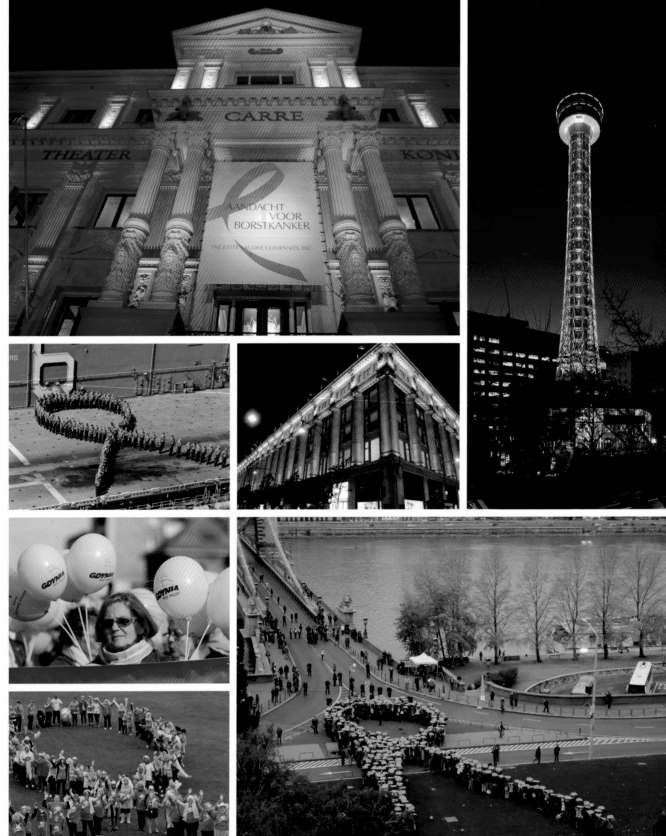

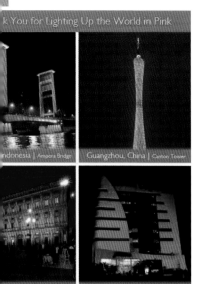

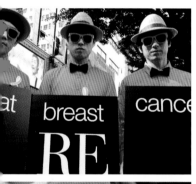

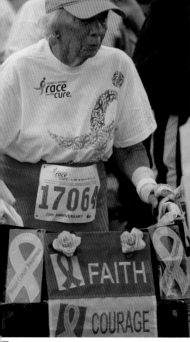

Pop Pink

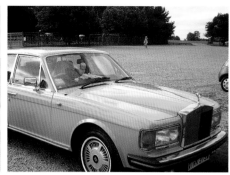

Catholic Purple

Roman Catholic bishops expressing their piety.

Rohani Purple

The colour of the progressive Iranian politician in the 2013 presidency elections.

Aristrocratic Purple

Associated with royalty, but used by politicians and leaders to approximate aristocratic status.

Graduation Purple

Ceremonial colour code for law, master of all academic education.

Los Milagros Purple

Celebrating the Lord of Miracles in Lima, Peru.

Voting Purple

Voter registration, the sign for democratic liberation from former dictatorships.

Feminine Purple

Originated in the 19th-century suffragette movement for women's voting rights, symbolising dignity.

Silent Purple

The combination of active (red) and calm (blue) chakras, linking the individual to the universal.

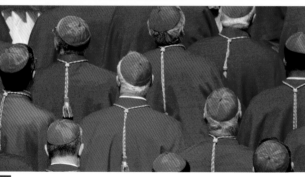
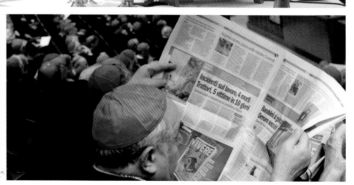

Rohani Purple

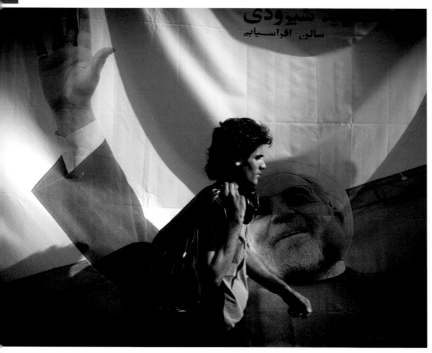

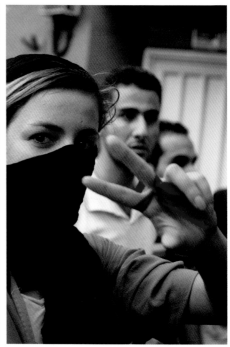

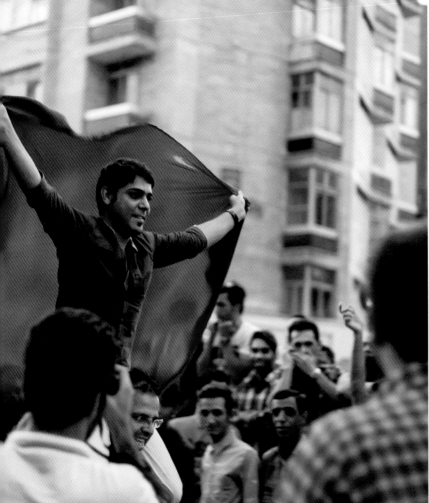

Aristocratic Purple

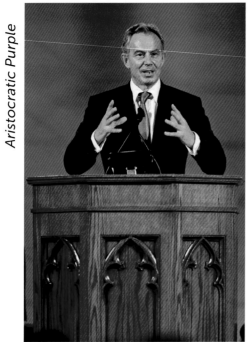

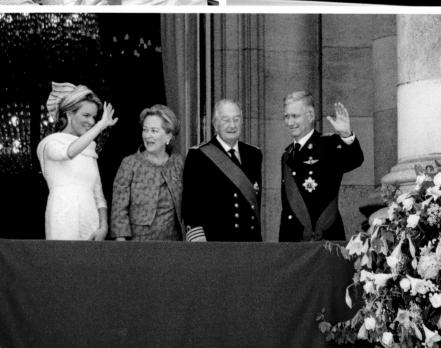

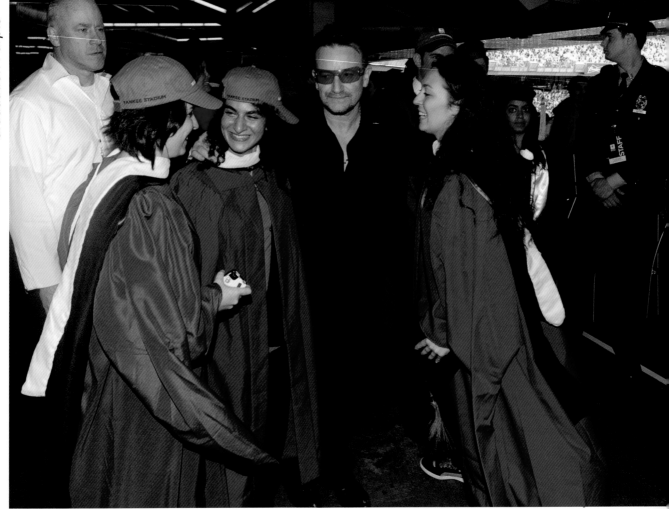

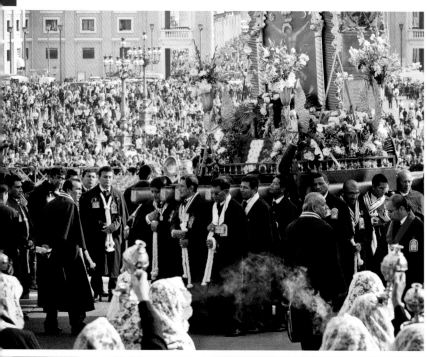

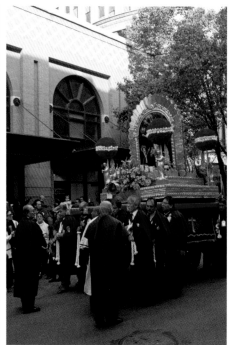

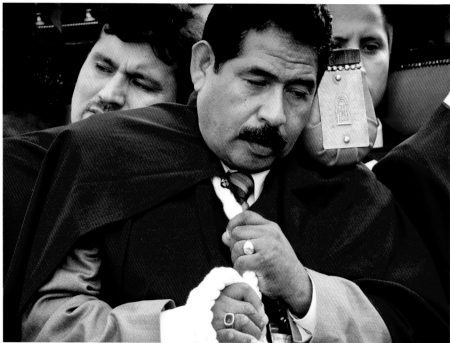

Voting Purple

Feminine Purple

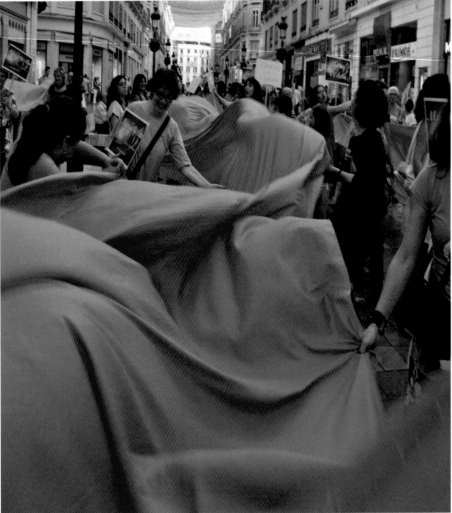

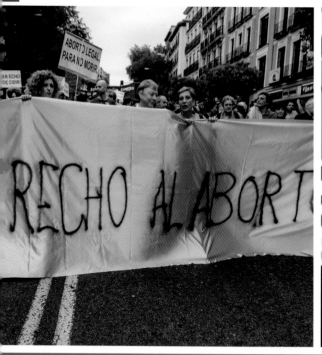

Silent Purple

Financial Blue
'Black' for finance:
trust added to authority.

Trust Blue
The backdrop of
trustworthiness.

Healthy Blue
Clean air, clean water,
the preconditions for health.

Social Blue
Ultimate generousity:
no interference in interaction.

Unlimited Blue
Infinity: Possibilities
beyond limits.

Peace Blue
The universal power
of humanity.

Blue Home
We choose to live free with
hardware-store-blue.

Sistema Blue
The social project of community
based music schools.

Clear Blue
Blue is the new green for
sustainability.

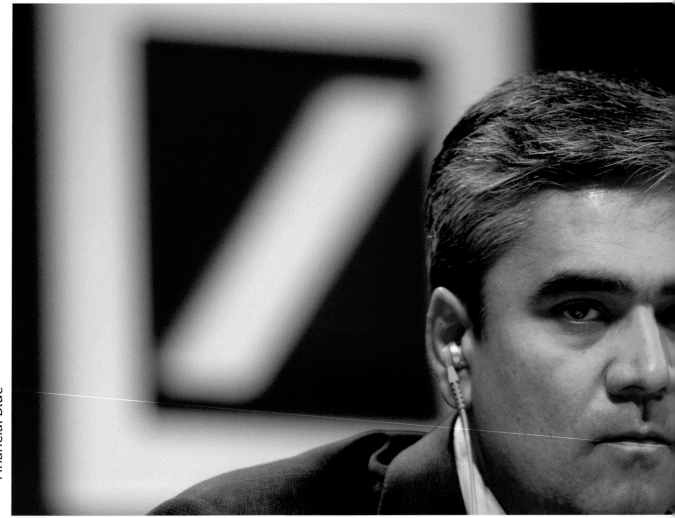

REFORMAR O
SISTEMA FINANCEIRO
O QUE SABEMOS
E O QUE PODEMOS
ANTECIPAR

London
Stock Exchange

Trust Blue

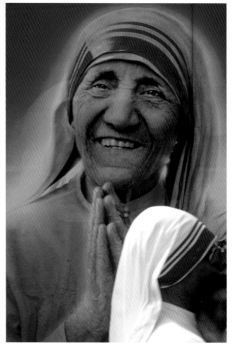

DEVELOPING STORY
AMERICA'S MONEY CRISIS
AC360° LIVE CNN
UPDATE Gas demand rises as price drops sharply 10:00 PM ET

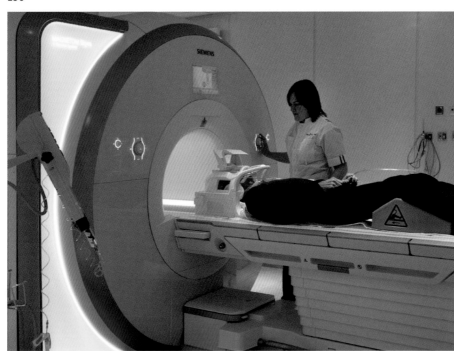

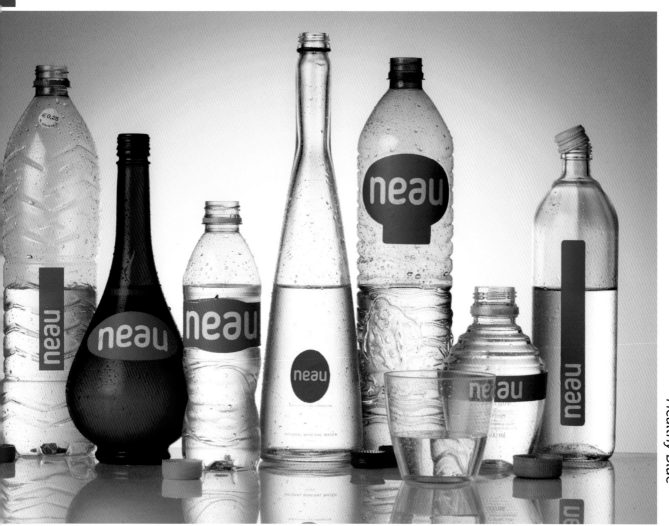

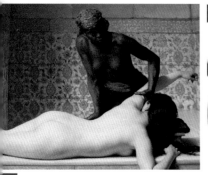

Social Blue

Pete Bergman :
- Seeing the world

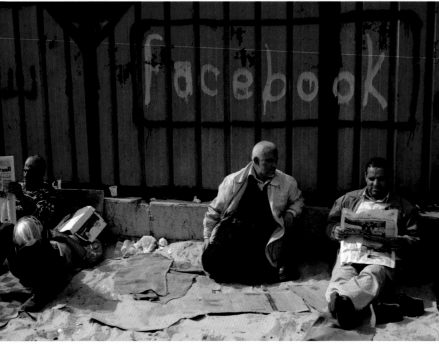

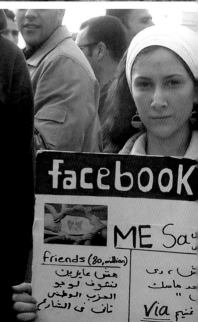

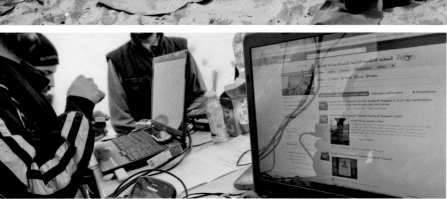

想要访问某个
应用程序,请释放
Command 和 Tab 键。

GENIU

160

Unlimited Blue

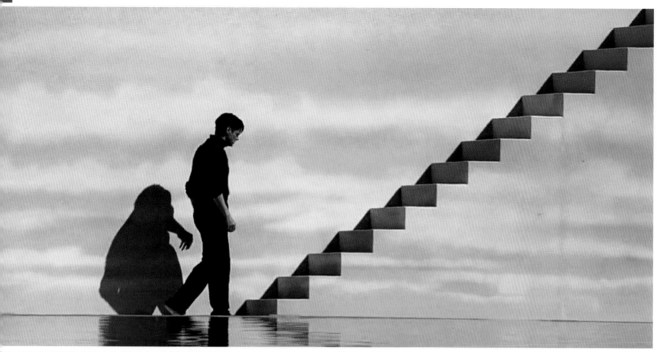

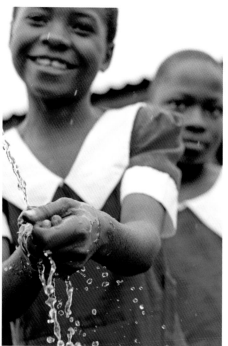
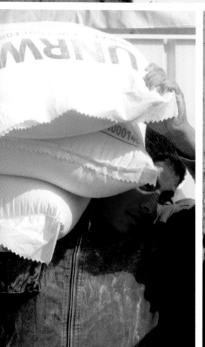
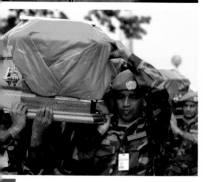
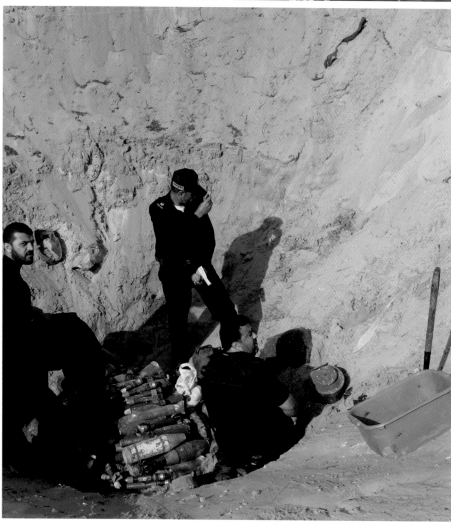

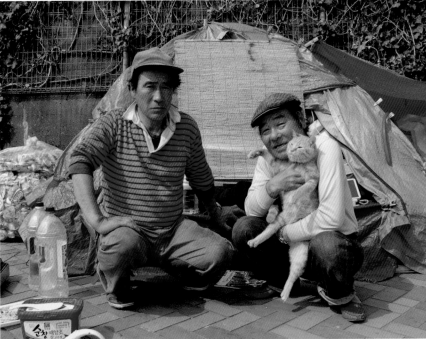

Nomadic Blue

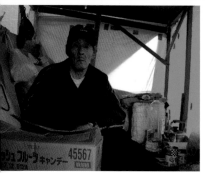

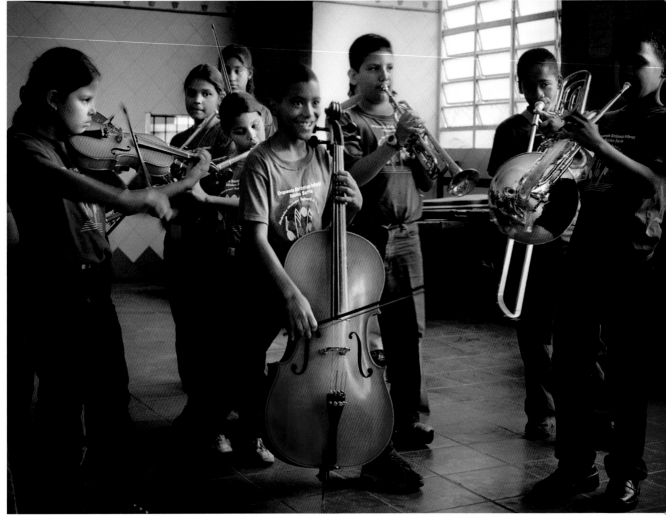

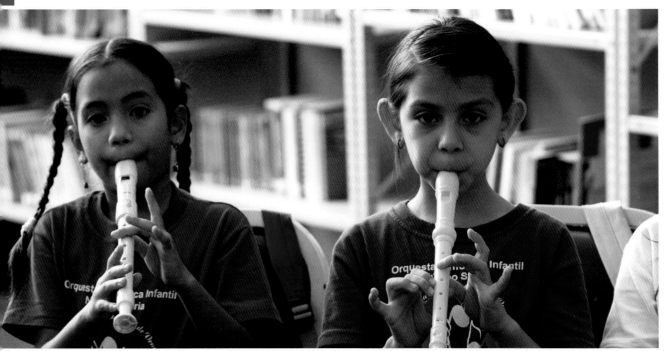

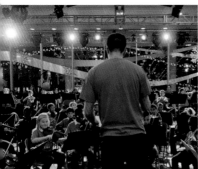

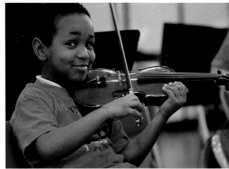

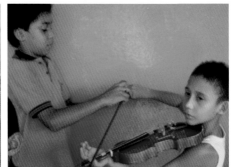

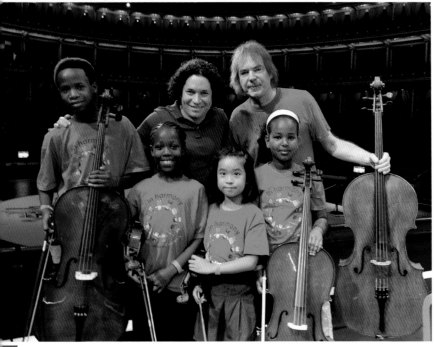

لكَ الهوّاء
الذي تتنفسُه

وأذرعتي تعانق السماء
لكي ثُبطّل مفعول ملوثات
الهواء بتقنية ذرات التيتانيا
المتناهية الصغر

Clear Blue

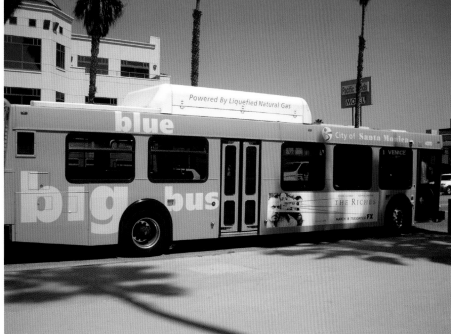

Black Mourning
Life ends in darkness; black expresses grief.

Safety Black
State authority without any personality.

Black Crime
The invisible colour absorbing all light.

Emo Black
Drowned in dark and heavy emotions.

Elegant Black
Optimum refinement, the 'black edition' of life.

Kiwi Black
The black kiwi bird adopted by the original New Zealand inhabitants.

Outcast Black
Rebels without a cause, the revenge of 'organised freedom'.

Black Rock
the color of rebels: Ramones, Patty Smith, Kiss, Nick Cave etc.

Minimal Black
The refusal of any decoration, driven by authenticity.

Black Mourning

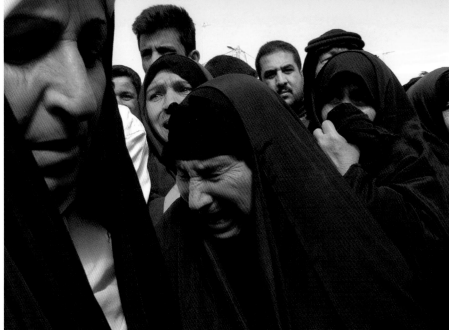

174

Safety Black

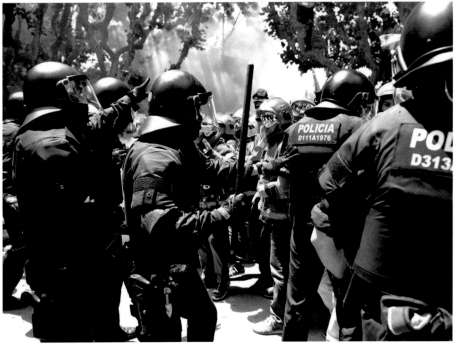
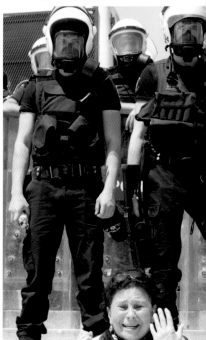

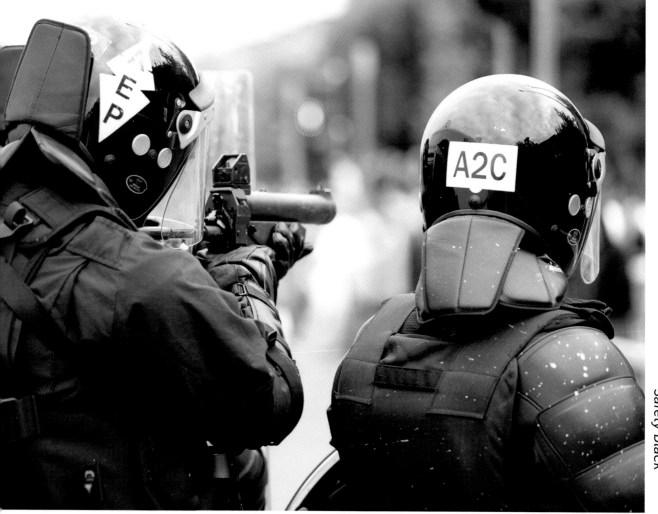

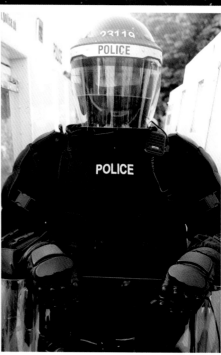

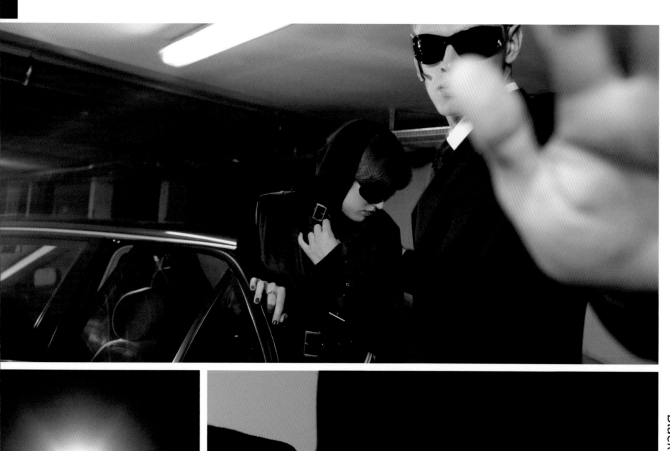

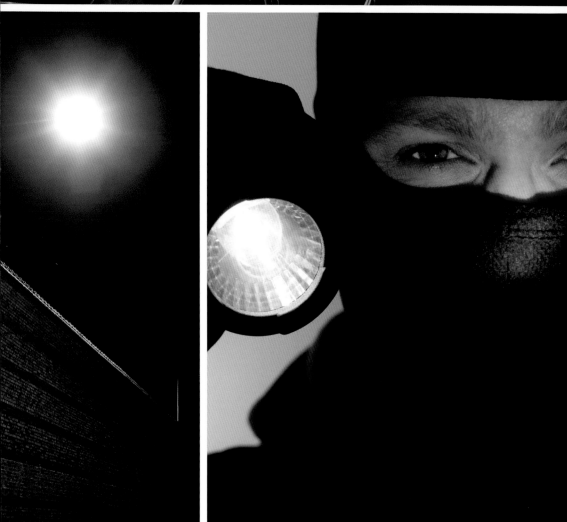

Emo Black

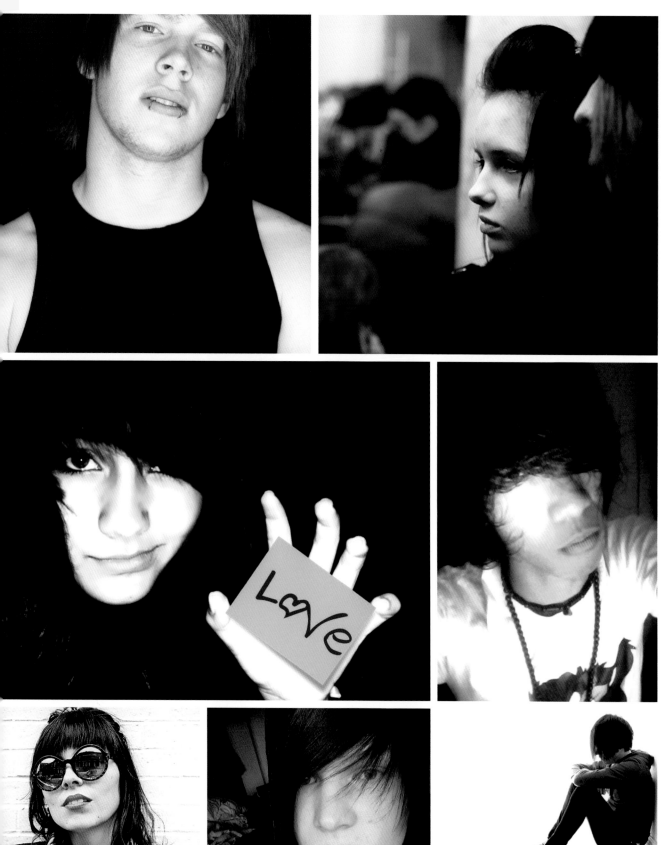

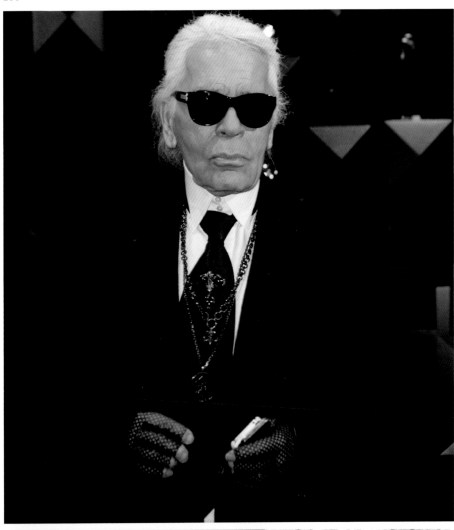

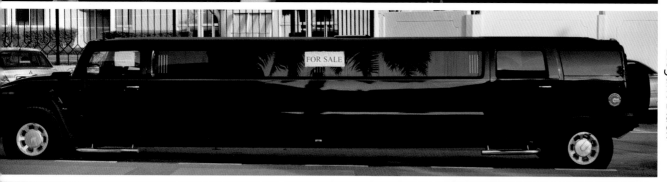

Nespresso. What else?

Kiwi Black

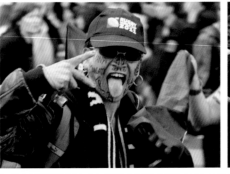

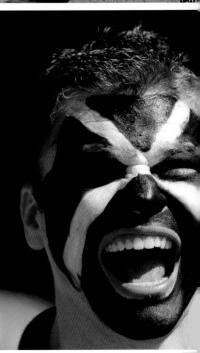

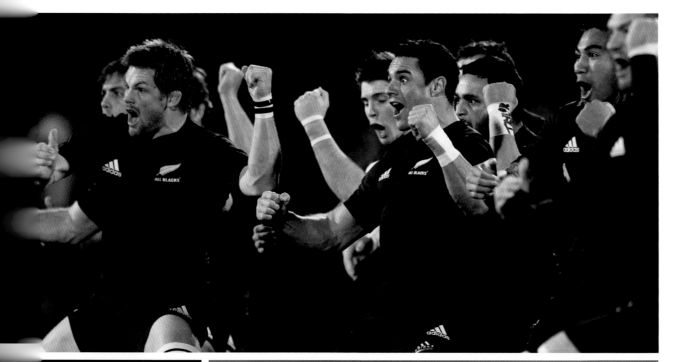

Kiwi Black

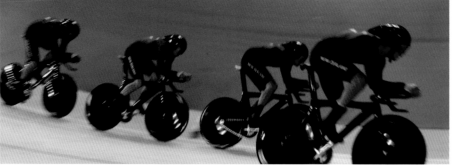

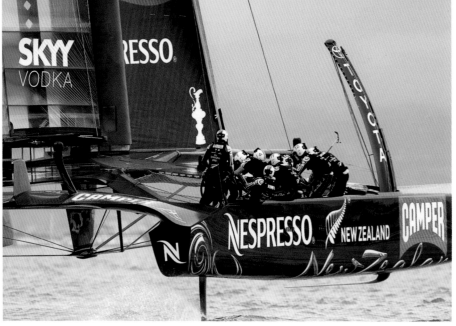

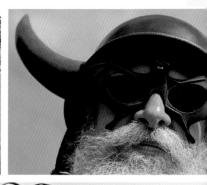

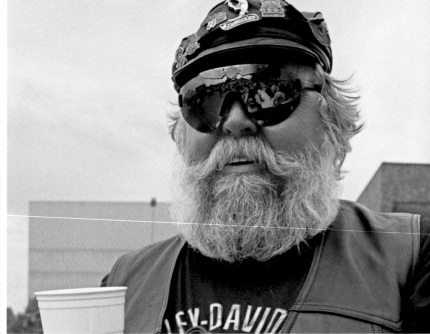

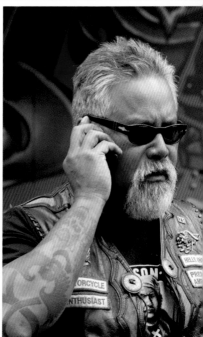

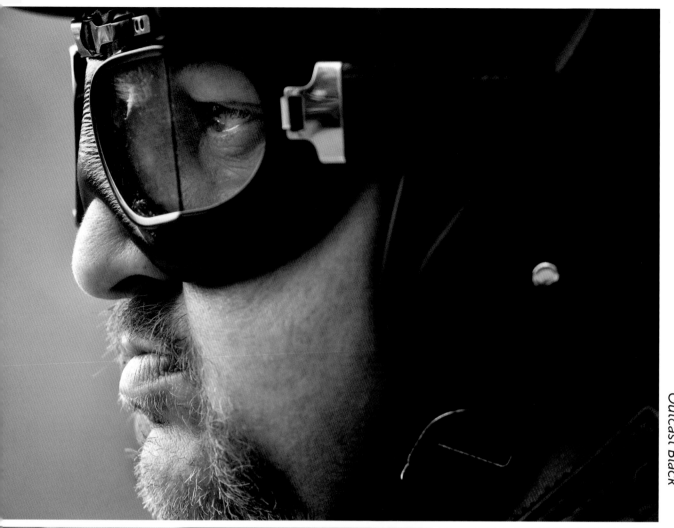

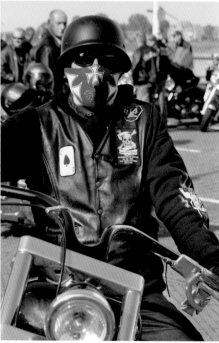

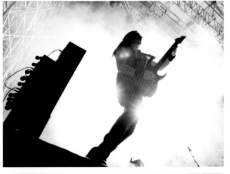

Black Rock

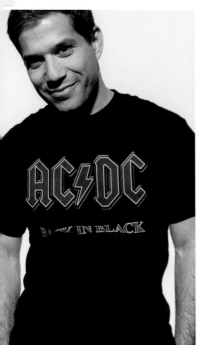

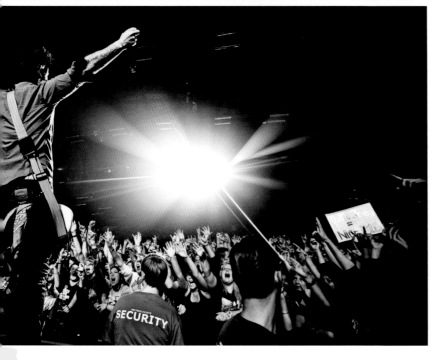

Minimal Black

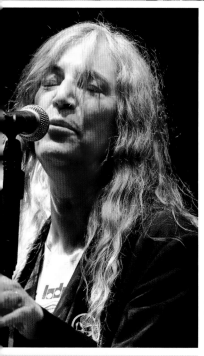

Piedmont, ITALY, 2010 (BIO)
s, dry spices, quince with
nuts and a long finish £ 27.50
nc "les Saulnier's" Montanet-Thoden
 FRANCE 2009 (Org)
)- It has liveliness and freshness £ 35.00

his wine has an excellent balance and
wonderful nose
 £ 27. 6
Rosso Dell'abazia, Serafini & Vidotto, Veneto
 ITALY 2003
Complex, creamy, and full based.
A red wine with it all
 £

Minimal Black

Index

Index